DECORATIVE ART
OF THE
SOUTHWESTERN INDIANS

By
DOROTHY SMITH SIDES

With annotations by
CLARICE MARTIN SMITH

and a Foreword by
FREDERICK WEBB HODGE
Director, Southwest Museum

DOVER PUBLICATIONS, INC.
NEW YORK

Published in Canada by General Publishing Company, Ltd., 30 Lesmill Road, Don Mills, Toronto, Ontario.

Published in the United Kingdom by Constable and Company, Ltd.

This Dover edition, first published in 1961, is an unabridged and corrected republication of the work originally published in portfolio format by the Fine Arts Press, Santa Ana, California, in 1936.

Standard Book Number: 486-20139-2
Library of Congress Catalog Card Number: 62-353

Manufactured in the United States of America
Dover Publications, Inc.
180 Varick Street
New York, N.Y. 10014

FOREWORD

That there was keen appreciation of the art of decoration among the American Indians, and especially on the part of the women, one need only glance at the selection made by the artist-author of this book to be convinced. Indeed so rich in esthetic quality was, and still is, much of the art product of the Indians of the United States alone, that the artist-author has been compelled to confine her immediate attention to that of the Southwest, leaving to the future the extension of her studies, let it be hoped, to the decorative art of the Indians of other fields.

Mrs. Sides has made from a vast amount of material, especially in the Southwest Museum, as comprehensive a selection as possible of the designs on pottery, basketry, and other artifacts of the Southwestern tribes, and in this manner has presented a fair impression of what those Indians have accomplished in early and in later times. The copies were faithfully made, while the reproductions are such as no one can reasonably criticize.

The demand for such a work on primitive art as the present one has grown with the increasing interest in Indian art and beliefs. Schools have undertaken the study of these subjects in a serious way, and there never have been so many devotees of American ethnology as at the present time. We commend the present work as one worthy of an honored place in the growing library of aboriginal American art.

F. W. HODGE

Southwest Museum
Los Angeles, California

ACKNOWLEDGMENTS

Grateful acknowledgment is given to all those who have assisted me. Most especially my Mother, without whose help, both material and mental, there would have been no book. To Florence Daly and Helen Evans, reference librarians of the Riverside Public Library; Winifred W. Britton, former Librarian of the Southwest Museum; Charles Avery Amsden for his timely advice and encouragement, and particularly to Dr. Frederick Webb Hodge, whose kindness, help and well-deserved criticism is most deeply appreciated. Lastly to Thomas E. Williams of the Fine Arts Press, for his courage, perhaps rashness, in printing this book.

LIST OF PLATES

LIST OF PLATES

LIST OF PLATES

LIST OF PLATES

BIBLIOGRAPHY

ALEXANDER, Hartley Burr.
1932

Pueblo Indian Painting.
C. Szwedzicki, Nice, France.

AMSDEN, Charles Avery.
1931

Black-on-White Ware.
In Kidder, A. V., Pottery of Pecos, vol. I.
Yale University Press, New Haven.

1934

Navaho Weaving.
Fine Arts Press, Santa Ana, California.

BOAS, Franz.
1897

The Decorative Art of the Indians of the
North Pacific Coast.
Bulletin of the American Museum of
Natural History, vol. IX, pp. 123-176,
New York.

BUNZEL, Ruth L.
1930

The Pueblo Potter.
Columbia University Press, New York.

CHAPMAN, Kenneth M.
1916

Evolution of the Bird in Decorative Art.
Art and Archaeology, vol. IV, no. 6, pp.
307-316, Washington.

1931

Indian Pottery.
Exposition of Indian Tribal Arts, New
York.

1933

Pueblo Indian Pottery, vol. I.
C. Szwedzicki, Nice, France.

COOLIDGE, Mary R.
1929

The Rain-makers.
Houghton Mifflin Co., Boston and New
York.

CRANE, Leo.
1925

Indians of the Enchanted Desert.
Little, Brown & Co., Boston.

1928

Desert Drums.
Little, Brown & Co., Boston.

BIBLIOGRAPHY

CURTIS, Edward S.
1907-1930

The North American Indian, 20 vols.
Cambridge and Norwood, Mass.

DIXON, Joseph K.
1904

The Vanishing Race.
Doubleday, Page & Co., New York.

DOUGLAS, F. H.
1933-1935

Leaflets of the Denver Art Museum, nos.
53-54, 69-70.

FEWKES, Jesse Walter.
1894

Dolls of the Tusayn Indians.
E. J. Brill, Leiden, Holland.

1897

Tusayan Katcinas.
Fifteenth Annual Report Bureau of Ethnology, pp. 245-313, Washington.

1901

Archaeological Expedition to Arizona in 1895.
Seventeenth Annual Report Bureau of American Ethnology, pt. 2, pp. 519-744.

1903

Hopi Katcinas.
Twenty-first Annual Report Bureau of American Ethnology, pp. 3-126, Washington.

1904

Two Summers' Work in Pueblo Ruins.
Twenty-second Annual Report Bureau of American Ethnology, pp. 3-195, Washington.

GODDARD, Pliny Earle.
1903-1904

Life and Culture of the Hupa.
University of California Publication in American Archaeology and Ethnology, vol. I, no. 1, Berkeley.

GUTHE, Carl E.
1925

Pueblo Pottery Making.
Yale University Press, New Haven.

HARRINGTON, Mark R.
1927

Form and Color in American Indian Pottery North of Mexico.
Reprinted from the Journal of American Ceramic Society, vol. X, no. 7, Columbus, Ohio.

HEWETT, Edgar Lee.
1930

Ancient Life in the American Southwest.
Bobbs-Merrill Co., Indianapolis.

BIBLIOGRAPHY

HODGE, Frederick Webb. Pottery of Hawikuh.
1923 Indian Notes, Museum of the American Indian, Heye Foundation, vol. VII, no. 1, New York.

HOLLISTER, U. S. The Navaho and his Blanket.
1903 Denver, Colorado.

HOLMES, William H. Pottery of the Ancient Pueblos.
1886 Fourth Annual Report Bureau of Ethnology, pp. 257-360, Washington.

1888 A Study of the Textile Art in it's Relation to the Development of Form and Ornament.
Sixth Annual Report Bureau of Ethnology, pp. 189-252, Washington.

JAMES, George Wharton. Indian Basketry.
1901 Privately printed for the author, Pasadena, California.

1914 Indian Blankets and their Makers.
A. C. McClurg & Co., Chicago.

1917 The Indian Secrets of Health.
Radical Life Press, Pasadena, California.

KIDDER, Alfred Vincent. Pottery of Pecos, vols. I-II.
1931-1936 Yale University Press, New Haven.

KISSELL, Mary L. Basketry of the Papago and Pima.
1916 Anthropological Papers of the American Museum of Natural History, vol. XVII. pp. 115-264, New York.

KROEBER, A. L. Types of Indian Culture in California.
1904 University of California Publications in American Archaeology and Ethnology, vol. II, no. 3, pp. 81-103, Berkeley.

Basket Designs of the Indians of North east California.
University of California Publications in American Archaeology and Ethnology, vol. II, no. 4, pp. 105-167, Berkeley.

BIBLIOGRAPHY

LAUT, Agnes C.
1913

Through our Unknown Southwest.
McBride, Nast & Co., New York.

LUMMIS, Charles F.
1893

Spanish Pioneers.
A. C. McClurg & Co., Chicago.

MASON, Otis Tufton.
1894

Woman's Share in Primitive Culture.
D. Appleton & Co., New York.

1904

Aboriginal American Basketry: Studies
in a Textile Art without Machinery.
Annual Report of the U. S. National Mu-
seum for 1902, pp. 171-548, Washington.

MATTHEWS, Washington.
1883

Navaho Silversmiths.
Second Annual Report Bureau of Eth-
nology, pp. 167-178.

1884

Navaho Weavers and their Work.
Third Annual Report Bureau of Eth-
nology, pp. 371-391.

1887

The Mountain Chant.
Fifth Annual Report Bureau of Ethnol-
ogy, pp. 379-467.

1891

Navaho Dyestuffs.
Annual Report of the Smithsonian Insti-
tution, pp. 613-615.

MINDELEFF, Victor.
1891

A Study of Pueblo Architecture; Tusay-
an and Cibola.
Eighth Annual Report Bureau of Eth-
nology, pp. 3-228.

NESBIT, Paul H.
1931

The Ancient Mimbreños.
Logan Museum, Beloit College, Wiscon-
sin.

PAYTIAMO, James.
1932

Flaming Arrow's People.
Duffield & Green, New York.

REICHARD, Gladys A.
1928

Social Life of the Navaho Indians.
Columbia University Press, New York.

BIBLIOGRAPHY

ROBERTS, Helen H.
1929

Basketry of the San Carlos Apache.
Anthropological Papers of the American Museum of Natural History, vol. **XXXI**, pt. 3, New York.

ROBINSON, William H.
1928

Under Turquoise Skies.
Macmillan Co., New York.

ROSEBERRY, T. A.
collection of
1915

Illustrated History of Baskets and Plates, made by California Indians and many other tribes.
Panama Pacific Exposition.

RUSSELL, Frank.
1908

The Pima Indians.
Twenty-sixth Annual Report Bureau of American Ethnology, pp. 3-389.

SEYMOUR, Flora W.
1929

The Story of the Red Man.
Longmans, Green & Co., New York.

SLOAN, John.
and
LA FARGE, Oliver.
1931

Introduction to American Indian Art.
Exposition of Indian Arts Inc.,
New York.

SPIER, Leslie.
1933

Yuman Tribes of the Gila River.
University of Chicago Press, Chicago.

STEVENSON, James.
1883

Illustrated Catalogue of the Collections Obtained from the Indians of New Mexico and Arizona in 1879.
Second Annual Report Bureau of Ethnology, pp. 407-422.

1891

Ceremonial of Hasjelti Dailjis.
Eighth Annual Report of Bureau of Ethnology, pp. 229-285.

STEVENSON, Matilda Coxe.
1904

The Zuñi Indians: their Mythology, Esoteric Fraternities, and Ceremonies.
Twenty-third Annual Report Bureau of American Ethnology, pp. 3-608.

WESTLAKE, Inez B.
1925

American Indian Designs, First Series.
H. C. Perleberg, New York.

BIBLIOGRAPHY

WHITE, Leslie A. The Acoma Indians.
1932 Forty-seventh Annual Report Bureau of
 American Ethnology, pp. 17-192.

Annual Reports of the Smithsonian Institution for 1884, 1891, 1928.

Annual Reports of the Bureau of American Ethnology for 1880-1881, 1882-1883, 1883-1884, 1884-1885, 1887-1888, 1893-1894, 1896-1897, 1899-1900, 1900-1901, 1901-1902, 1904-1905, 1929-1930.

DECORATIVE ART
OF THE
SOUTHWESTERN INDIANS

Plate 1

PUEBLO VIEJO, ARIZONA. ANCIENT PUEBLO GROUP
POTTERY DESIGNS

Reference:
Two Summers' Work in Pueblo Ruins.
Jesse Walter Fewkes,
Twenty-second Annual Report Bureau of American Eth-
nology, 1904, pp. 3-195.

a Plate LXIX, No. 177536a
b Plate LXVIII, No. 177521
c Plate LXIX, No. 177558c

The ruins of Pueblo Viejo are in the valley of the Gila river, Graham County, Arizona.

The designs of Pueblo Viejo pottery consist almost entirely of rectangular figures; examples of picture-writing are not found, nor pictures of birds, showing that the ancient inhabitants had not carried decoration beyond the geometrical stage. Their pottery was divided into the following classes; undecorated rough ware, decorated rough ware, undecorated red ware, decorated black-on-white ware, and decorated gray ware. An unusual feature of the decoration is, that the margin of the design is white. The decoration is both on the interior and exterior of vessel, and consists of rectangular bands and series of terraced figures, a prominent characteristic of all ancient pottery from Arizona.

PLATE 1

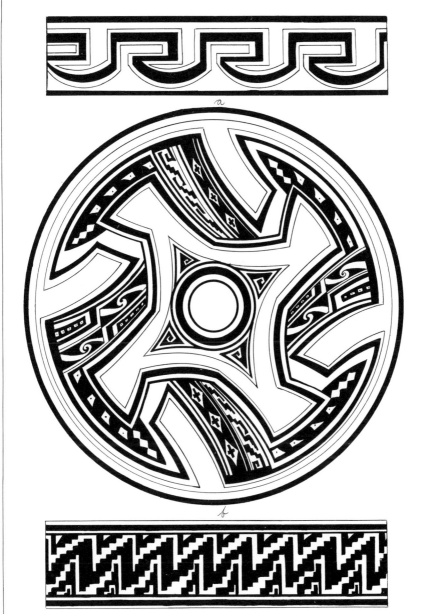

a

b

c

Plate 2

FOUR MILE RUIN, ARIZONA. ANCIENT PUEBLO GROUP
POTTERY DESIGNS

Reference:

Two Summers' Work in Pueblo Ruins.
Jesse Walter Fewkes,
Twenty-second Annual Report Bureau of American Ethnology, 1904, pp. 3-195.

a Plate XXVI, No. 177203
b Plate LX, No. 177048a
c Plate XLI, No. 177223a

Four Mile Ruin is situated about two miles from Taylor, Arizona, and is one of the largest ruins in the vicinity.

The pottery found here, characteristically the same as that from the Chevlon and Homolobi ruins, consists of a decorated, and a rough coiled ware, the former prevailing. There is also a great similarity in the coarse pottery from Four Mile Ruin and that of Pueblo Viejo. The picture-writing on this pottery is highly instructive; bird figures are particularly abundant, also representations of human beings, reptiles, and insects. The picture-writing of each pueblo has an individuality which seems to indicate that it was independently developed, that certain forms or patterns were adapted to special ideals. The cause of this divergence in the designs is no more comprehensible than the difference in the decoration of modern pottery from the various pueblos.

PLATE 2

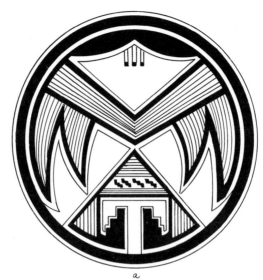

a

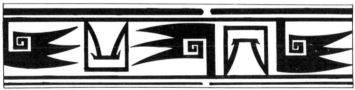

b

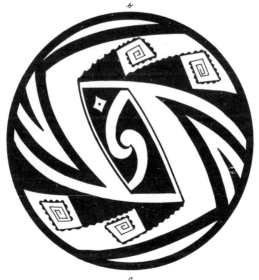

c

Plate 3

FOUR MILE RUIN, ARIZONA. ANCIENT PUEBLO GROUP
POTTERY DESIGNS

Reference:
Two Summers' Work in Pueblo Ruins.
Jesse Walter Fewkes,
Twenty-second Annual Report Bureau of American Eth-
nology, 1904, pp. 3-195.

a Plate LXIII, No. 177162a
b Plate XL, No. 177219a
c Plate LIX, No. 177160b

Figures of birds predominate in the decoration of the pottery from many ancient
pueblos. In the delineation of bird figures the artists took strange liberty with nature.
In all representations of mythical animals the imagination had full sway. The por-
trayal was not that of a familiar bird, but a creature of fancy, distorted by mythological
conception or the whim of the artist.

Representations of feathers, often highly conventionalized, are freely used in
the designs on ancient pottery. One feather symbol is the triangle, a form of which
is still present in modern ceremonial paraphernalia. This type of feather design is
common, but is more difficult to recognize than that of the ancient Hopi.

PLATE 3

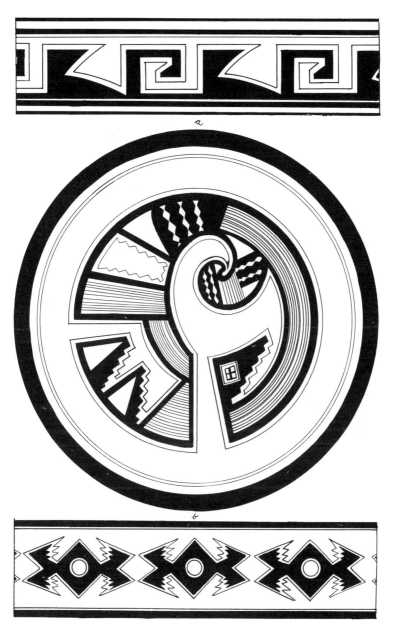

Plate 4

FOUR MILE RUIN, ARIZONA. ANCIENT PUEBLO GROUP
POTTERY DESIGNS

Reference:
Two Summers' Work in Pueblo Ruins.
Jesse Walter Fewkes,
Twenty-second Annual Report Bureau of American Ethnology, 1904, pp. 3-195.

a Page 150, fig. 96, No. 177058
b Plate XXV, No. 177293a
c Page 157, fig. 105, No. 157352
d Plate LXIII, No. 177147b
e Plate XL, No. 177086b
f Plate XXV, No. 177110b

The geometric decoration of pottery was common in all ancient pueblos. The types were terraced figures, spirals, frets, bands, dotes, oblique and zigzag lines. The proportion of geometric figures to that of animals was large.

The principal decoration was confined to the interior of bowls, but many are found decorated with external banding. Figures of animals, unless highly conventionalized, and spirial designs, are rare, although straight lines and rectangular figures were often employed.

Symbolic rain-cloud forms, combining the rectangle, semicircle, and the triangle, were freely used, the rectangle being the most common.

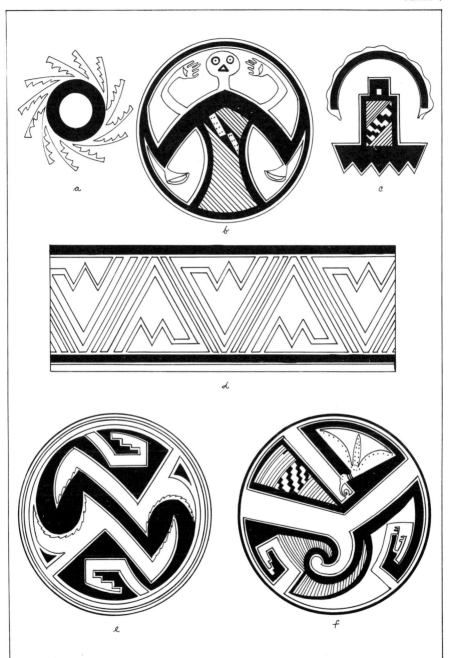

PLATE 4

Plate 5

MIMBRES, NEW MEXICO. ANCIENT PUEBLO GROUP POTTERY DESIGNS

References:
 Southwest Museum
 The Ancient Mimbreños
 Paul H. Nesbit
 Ancient Life in the American Southwest
 Edgar Lee Hewett

a
b
c Specimens from Southwest Museum
d
e

Ruins in the valley of the Rio Mimbres extend from an unknown distance below Deming to the headwaters of the stream in southeastern New Mexico.

The pottery is black-on-white ware and the standard form is the bowl, which is relatively deep and well finished. The decoration is usually confined to the interior of the bowl; the design is well executed, with a delicacy of line and an accuracy of spacing unequaled in other ancient pottery of the Southwest.

Aside from the extraordinary geometric designs, there is a profusion of naturalistic drawings, ranging from evidently mythical figures, to birds, animals, fishes, insects, and human beings.

True naturalism is so rare a phenomenon in all Southwestern pottery decoration, particularly in its early phases, marked by black-on-white wares, that its very high development is puzzling.

Certain bowls used as mortuary vessels, being placed over the head in burials, were always pierced in the base or "killed" to allow the egress of the spirit of the vessel to accompany the soul of the dead to its future world.

PLATE 5

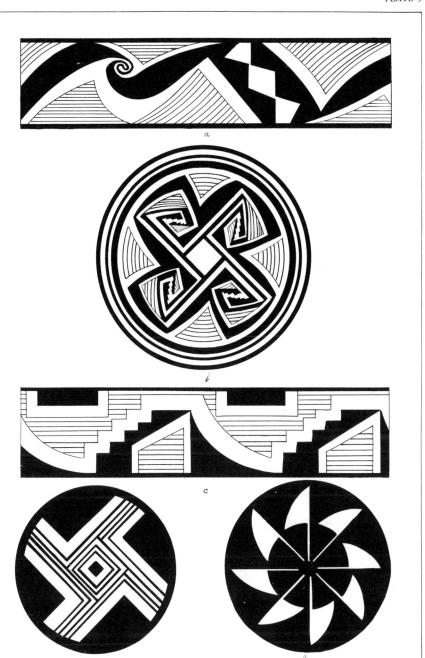

a

b

c

d

e

Plate 6

MIMBRES, NEW MEXICO. ANCIENT PUEBLO GROUP
POTTERY DESIGNS

References:
The Ancient Mimbreños
Paul H. Nesbit
Ancient Life in the American Southwest
Edgar Lee Hewett
Indian Pottery
Kenneth M. Chapman

a Page 352, Edgar Lee Hewett
b Page 352, Edgar Lee Hewett
c Page 352, Edgar Lee Hewett
d Page 352, Edgar Lee Hewett
e Page 9, Kenneth M. Chapman
f Page 352, Edgar Lee Hewett

The ancient Mimbres people probably surpassed all other ancient Pueblo groups in their art, but they continued to live in pit houses, owing to the intense heat of the Mimbres valley. Although their living conditions remained the same, it was not so with their pottery.

All forms of corrugated ware, used principally for cooking, were familiar to them, and consisted mostly of food bowls with a gray background and black decoration; occasionally there is found black-on-white ware. Their geometric designs were not superior to those of potters of the western slope; however, their life forms were most striking, and in these motifs they were master artists.

These potters developed an esthetic imagination which produced an abundance of beautiful earthenware. The Mimbres valley is rightfully termed an "Ancient Art Province."

PLATE 6

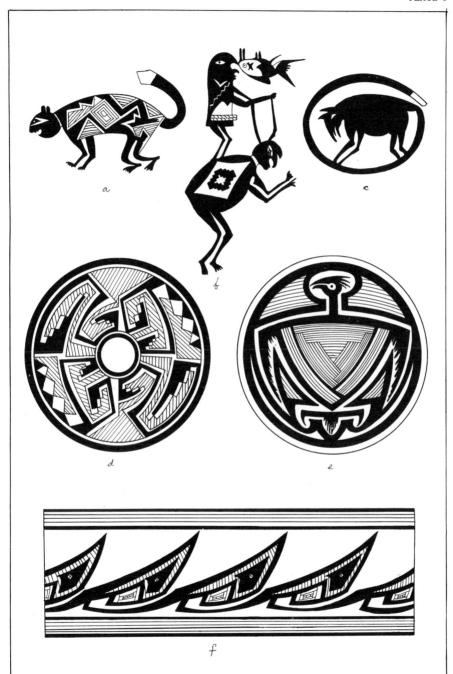

a

b

c

d

e

f

Plate 7

The commonly accepted definition of Sikyatki, "yellow house," so far as the general color of the pueblo is concerned, does not seem to be particularly appropriate; but the name may refer to a cardinal point, a method of symbolic nomenclature followed in the Southwest. The origin of Sikyatki is doubtful, however its builders and occupants are supposed to have come into Hopiland from the valley of the Rio Grande in late prehistoric times. It is almost impossible to estimate the population of this pueblo at the time it flourished, but probably it did not exceed three hundred to five hundred.

PLATE 7

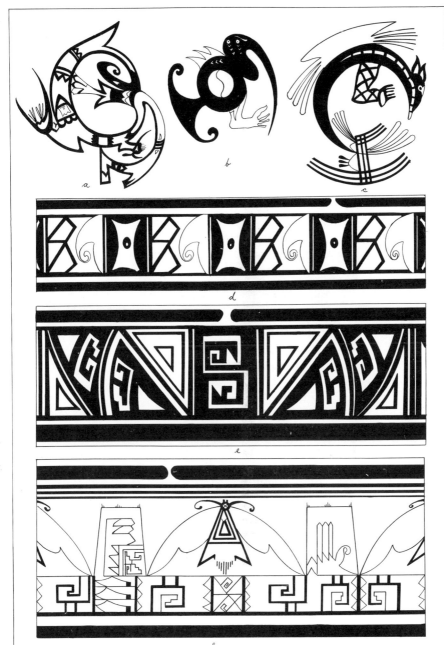

Plate 8

Sikyatki, Arizona. Ancient Pueblo Group
Hopi Province
Pottery Designs

Reference:
Archeological Expedition to Arizona in 1895.
Jesse Walter Fewkes,
Seventeenth Annual Report Bureau of American Eth-
nology, 1901, pt. 2, pp. 519-744.

a Plate CLII, d
b Plate CLVII, a
c Plate CLIII, b
d Plate CXLVIII, d
e Plate CXLVII, d
f Plate CXLVII, e
g Plate CL, a
h Plate CXLVIII, c
i Plate CLIV, b
j Plate CLI, c

Sikyatki pottery is divided into three classes: (1) coiled and indented ware; (2) smooth, undecorated ware; (3) polished decorated ware. This pottery shows little or no duplication in decorative design, and every object bears different symbols. The decoration is chiefly on the interior of bowls, with geometric designs on the upper exterior. The first class, coiled ware, is coarse, not polished, and usually not decorated; the second class, undecorated ware, is as fine as that with painted designs; the third class, polished ware, of which there is the greatest amount, has more or less complicated designs and for this reason affords a more alluring subject for study than the other two classes.

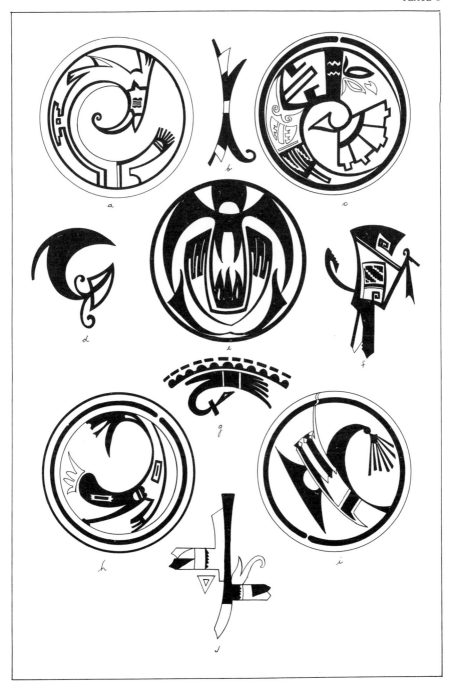

PLATE 8

Plate 9

SIKYATKI, ARIZONA. ANCIENT PUEBLO GROUP
HOPI PROVINCE
POTTERY DESIGNS

Reference:
Archeological Expedition to Arizona in 1895.
Jesse Walter Fewkes,
Seventeenth Annual Report Bureau of American Ethnology, 1901, pt. 2, pp. 519-744.

In the decoration of Sikaytki ware mythical concepts are sometimes portrayed, as the plumed snake. Reptiles, frogs, tadpoles, and insects are also fairly common. Plants and leaves are seldom employed, but flowers are sometimes used. Probably the most general motif found on the decorated pottery of Sikyatki is the feather, conventionalized, an important feature in the decoration of ancient Sikyatki and other Southwestern pottery. The employment of naturalistic ornament led to the use of rich and varied colors, chiefly yellow, red, black, and white.

PLATE 9

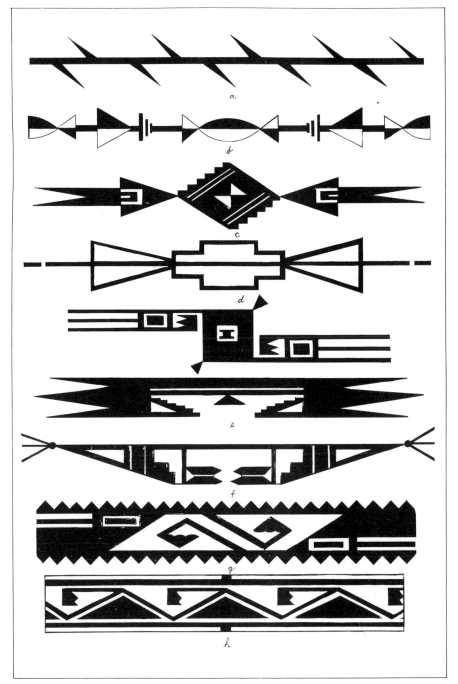

Plate 10

SIKYATKI, ARIZONA. ANCIENT PUEBLO GROUP
HOPI PROVINCE
POTTERY DESIGNS

Reference:

Archeological Expedition to Arizona in 1895.
Jesse Walter Fewkes,
Seventeenth Annual Report Bureau of American Eth-
nology, 1901, pt. 2, pp. 519-744.

a Page 722, fig. 335
b Page 683, fig. 272, plate CXXXVII, a
c Plate CXLIV, a

Birds and feathers far exceed all other motifs in the decoration of ancient Sikyatki pottery, the former being probably the first animal employed for that purpose. The food bowls thus decorated supply an abundance of material for scientific and esthetic study.

There is no reasonable doubt that figure 272, page 683, represents a bird, to which is attached a headdress of highly modified feather ornament. On each side of the body are undoubtedly wings, with feathers continued into arrowpoints. The tail is composed of three large feathers projecting beyond two triangular extensions, marking the end of the body.

On the upper surface of the vase are four similar designs representing birds of the four cardinal points. The wings consist of triangular extensions; each bird has four tail-feathers and rain-clouds on the anterior end of the body.

PLATE 10

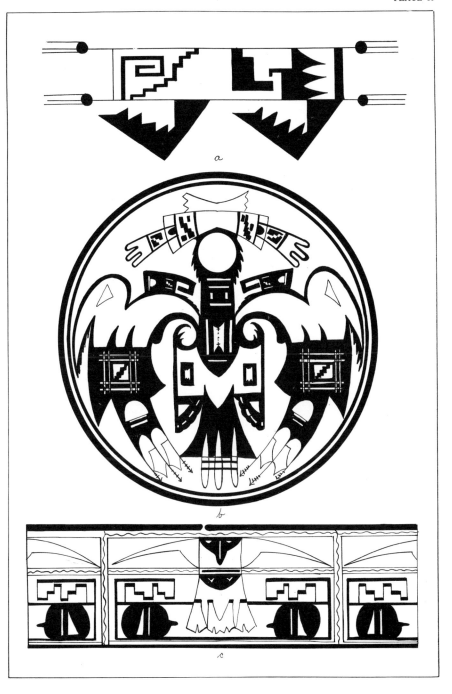

a

b

c

Plate 11

Reference:
Two Summers' Work in Pueblo Ruins.
Jesse Walter Fewkes,
Twenty-second Annual Report Bureau of American Ethnology, 1904, pp. 3-195.

a Page 117, fig. 73, No. 157771
b Page 114, fig. 69, No. 157769
c Page 114, fig. 68, No. 157817
d Plate LI, No. 157784 a
e Plate L, b
f Page 117, fig. 72, No. 157134
g Page 115, fig. 70, No. 157714

Comparatively little pottery has been excavated at the ancient site of the Hopi pueblo of Shongopovi, but the majority of that found consists of fine yellow ware smoothly polished and elaborately decorated. There is no essential difference in the forms of the pottery from this ruin and that from the pueblos on the Little Colorado. The picture-writing on Shongopovi ware closely resembles that on ware from ruins near the East Mesa of Hopiland. On the whole, old Shongopovi pictography is very similar to that of Sikyatki. Specimen b is an entirely different representation of the plumed snake, the feathers being represnted by two semicircular figures and the tongue by a line terminating in an arrowpoint. Many bird forms are present, with a close likeness to those of Sikyatki. A peculiar conventionalized form of "breath feather" here may lead one to regard this as a part of the mythical bird-man god.

PLATE 11

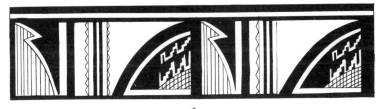

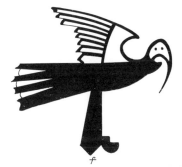

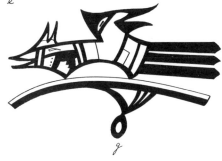

Plate 12

Reference:
Two Summers' Work in Pueblo Ruins
Jesse Walter Fewkes,
Twenty-second Annual Report Bureau of American Ethnology, 1904, pp. 3-195.

a Plate XXII, No. 157588, a
b Page 82, fig. 37, No. 156888
c Plate XLIII, No. 156494, b
d Page 76, fig. 31, No. 156603
e Plate XXXIII, No. 156489, b
f Plate XXXII, No. 156621, b

While four ruins are called Homolobi, ruin no. 1, situated three miles from Winslow, Arizona, is designated as the true Homolobi. It was a small pueblo of irregular shape, one exceptional feature of which is that the pottery was not buried with the dead as customary mortuary offerings.

Many beautiful examples of pottery have been found not far from the ruins of Homolobi, covered with pictographs which closely resemble those found in other parts of the pueblo area.

PLATE 12

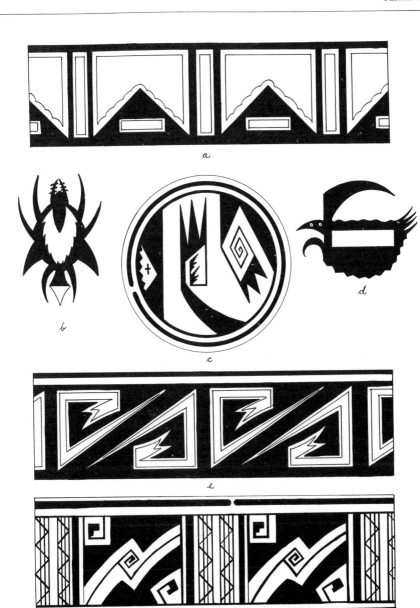

Plate 13

TESUQUE, NEW MEXICO. PUEBLO GROUP
POTTERY DESIGNS

References:
Pueblo Indian Pottery, vol. 1, 1933.
 Kenneth M. Chapman
Leaflets of the Denver Art Museum, 1933-1935,
 Nos. 53-54, 69-700.
 F. H. Douglas

a No. 61, Leaflets of the Denver Art Museum
b Plate 28, Chapman
c No. 6, Plate 31, Chapman

The pottery of the present pueblo of Tesuque, New Mexico, was until recently quite distinctive from that of the other pueblos, the warm grayish slip being decorated in black only. The designs were complex, being built up of familiar symbols—the trefoil, meander, naturalistic leaf forms, and the plumed serpent which was typical of all Pueblo designs. These in combination form unique decorative elements.

Tesuque potters of the present generation have unfortunately given up the production of this traditional ware and now either imitate the products of other Pueblos or produce quantities of small earthenware articles gaudily decorated with aniline colors and designed solely for sale to white tourists.

PLATE 13

a

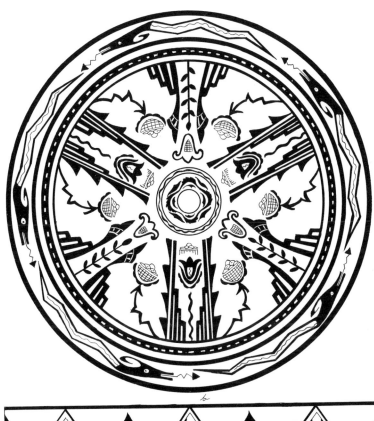

b

c

Plate 14

PECOS, NEW MEXICO. PUEBLO GROUP
POTTERY DESIGNS

References:
Pottery of Pecos, vols. I-II, 1931-1936.
Alfred Vincent Kidder
Black-on-White Ware
Charles Avery Amsden
In A. V. Kidder, Pottery of Pecos, vol. I, 1931.

a Page 69, fig. 18, a
b Page 79, fig. 24, f
c Page 69, fig. 18, b
d Page 65, fig. 16, d
e Page 149, fig. 90, k
f Page 115, fig. 68, b
g Page 69, fig. 18, d
h Page 87, fig. 34, h
i Page 69, fig. 18, h

The pueblo of Pecos, abandoned in 1838, was known to have been inhabited as early as 1200 A. D. The pueblo became one of the largest and most important in the Southwest.

The Pecos women were excellent potters, and as their mode of living required pottery for cooking and serving food, as well as for carrying and storing water, a variety of receptacles were manufactured.

A profusion of black-on-white ware will be found, also a biscuit type consisting of a light tan or brown background with a black design. The interior of the bowls was the favorite area for the Pecos decorator; the design was usually in bands which began a little below the rim and extended to the line forming the bottom. Gradually the style changed and many new designs were introduced.

PLATE 14

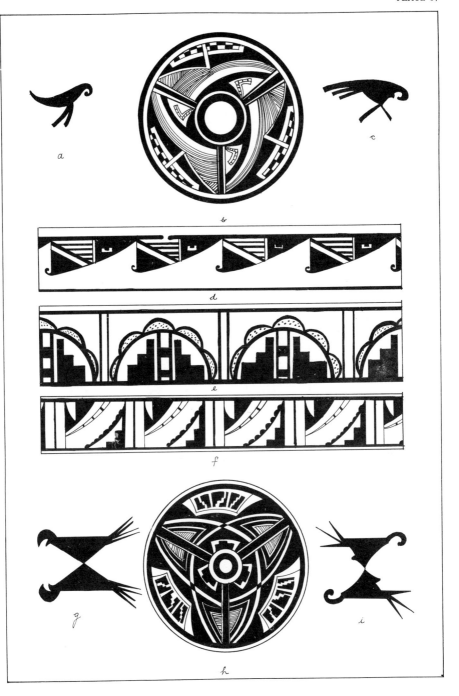

a

b

c

d

e

f

g

h

i

Plate 15

CHEVLON, ARIZONA. ANCIENT PUEBLO GROUP
(SHAKWABAIYKI)
POTTERY DESIGNS

Reference:
Two Summers' Work in Pueblo Ruins
Jesse Walter Fewkes,
Twenty-second Annual Report Bureau of American Ethnology, 1904, pp. 3-195.

a Plate XXXVIII, a No. 157119
b Page 78, fig. 33, No. 157264
c Page 83, fig. 38, No. 156138
d Page 79, fig. 34, No. 157084
e Plate XXXV, a No. 157406
f Plate XXXVIII b No. 157184

The Chevlon ruin called Shakwabaiyki by the Hopi, or Blue Running Water Pueblo, is near Winslow, Arizona. The country at this point is sandy and almost barren of vegetation.

The pottery from Chevlon is distinctive, and excellent in craftmanship, with a general likeness to that from other Arizona localities. It is more varied in character than that from the true Hopi ruins, though in decoration there is much resemblance. While in the ruins of Chevlon there were many glazed bowls, pots, and jars, at Sikyatki no glazed pottery was found.

PLATE 15

a

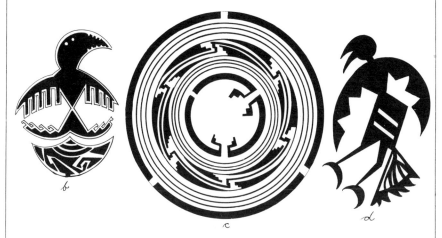

b

c

d

e

f

Plate 16

Development of Bird Symbols
Pottery Designs

Reference:

Evolution of the Bird in Decorative Art.
Kenneth M. Chapman,
Art and Archaeology, vol. IV, No. 6, 1916, pp. 307-316.

Of all forms employed as decorative motifs in primitive art, the bird has had the most widespread use. It has been a most adequate symbol in all aboriginal American art and particularly in the Pueblo area. The restricted use of conventionalized life forms is felt in the decoration of pottery, in which many motifs are taken from textile or basketry designs and retain their angular character though continually repeated.

Two types of pottery have furnished a profusion of material for the study of bird motifs, the biscuit ware and glazed ware from Pajarito Plateau of New Mexico. The greatest variety of treatment is found in the symbols from the glazed ware, and a large collection of these figures shows an unusual change from the realistic to forms which bear no resemblance to birds.

PLATE 16

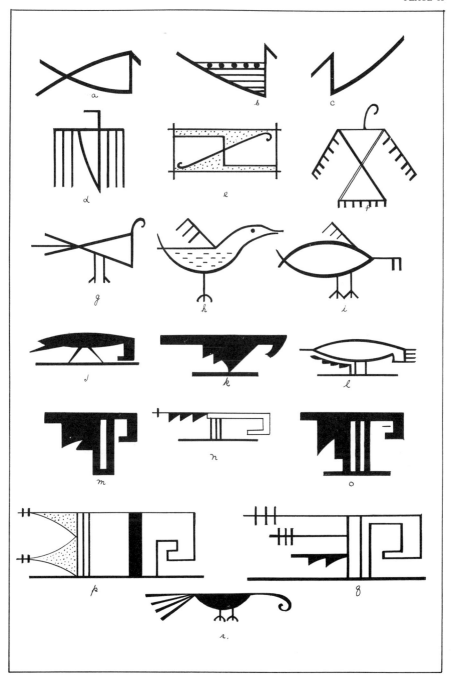

Plate 17

TRIBAL BIRD FORMS
POTTERY DESIGNS

Reference:
Evolution of the Bird in Decorative Art.
Kenneth M. Chapman,
Art and Archaeology, vol. IV, No. 6, 1916, pp. 307-316.

a Page 316, San Ildefonso
b Page 316, San Ildefonso
c Page 316, Zuñi
d Page 315, Zuñi
e Page 315, Zuñi
f Page 316, Acoma
g Page 316, Acoma
h Page 316, Hopi
i Page 316, Hopi

In bird designs the rectangular form of a crooked head is the dominant characteristic. The greatest divergence is found in that part of each figure corresponding with the tail in the more realistic bird; this comes under the division of serrate, stepped, triangular, or linear, and is sometimes double or multiple in form.

The production of pottery is still an important industry in most of the Pueblos of New Mexico and Arizona. The designs of Cochiti and Santo Domingo, neighboring pueblos, show great similarity, though even here some small distinction is easily discovered.

PLATE 17

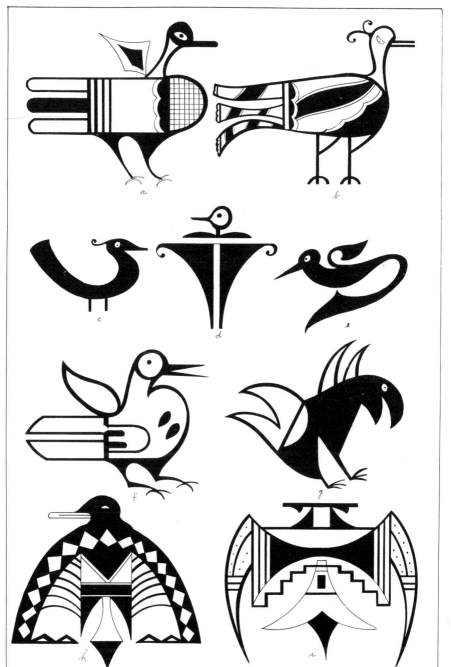

Plate 18

HOPI KACHINAS

References:
Hopi Katcinas.
 Jesse Walter Fewkes,
Twenty-first Annual Report Bureau of American Eth-
nology, 1903, pp. 13-126.
Tusayan Katcinas,
 Jesse Walter Fewkes,
Fifteenth Annual Report Bureau of Ethnology, 1897,
pp. 39-48.
Dolls of the Tusayan Indians
 Jesse Walter Fewkes

a Sio Humis Kachina, Southwest Museum
b Plate XXXIII, Hokyana Kachina, 21st Report
c Plate XXXIX, Kau Kachina, 21st Report
d Sio Kachina, Southwest Museum

The Hopi Indians represent their gods in several ways, one of which is by per-
sonations, which are supposed to have magic power, capable of action for good or
evil.

Various symbols have been adopted to represent this power, and are portrayed
by "Kachinas" which are objects carved from wood or modeled in clay. The greatest
care is given to the representation of the head, and its size is generally out of proportion
to the other parts. It is painted in gay colors with various symbols.

Each clan, it seems, as it joined the Hopi population, brought its own gods repre-
sented by their kachinas. These were given to their children who were taught the
tribal legends, the heroic deeds of their ancestors, and the virtues of truth, honesty, and
chastity, by the medicine-men or the old women. Each doll has a name and different
characteristic markings; the representation of clouds, in some form, is very general,
and is supposed to have a spiritual significance, regarding water as the symbol of the
spirit, and prayer for rain—a prayer for that spiritual strength which comes only
through opening the heart to God.

PLATE 18

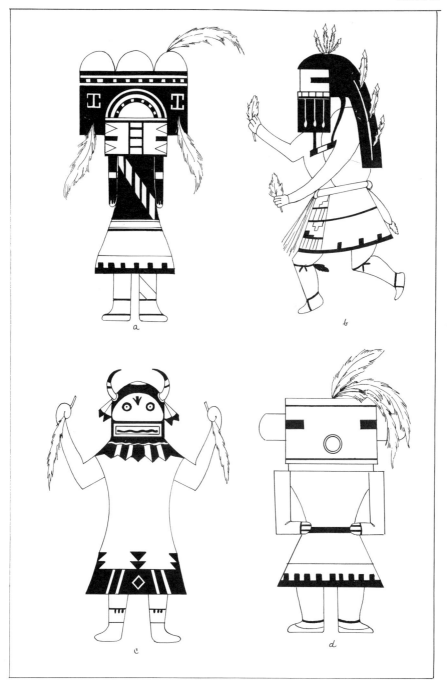

a

b

c

d

Plate 19

References:
Leaflets of the Denver Art Museum, 1933-1935,
Nos. 53-54, 69-70.
F. H. Douglas
Pueblo Pottery Making
Carl E. Guthe
Southwest Museum

a No. 64, F. H. Douglas
b No. 66, F. H. Douglas
c Plate III c, Carl E. Guthe
d Southwest Museum

Velino Shigi is an example of an Indian artist who has become very well known; he finished the fifth grade in the Government school at Santa Fe, when, untaught in the art of drawing or color, he was allowed to go on in the native method, in which no one can teach the Indian, and as a consequence one finds many beautiful examples of his art. With the Indian there is never any experiment with color or design, as the picture is mentally completed and then executed with precision.

PLATE 19

a

b

c

d

Plate 20

SIA, NEW MEXICO. PUEBLO GROUP
POTTERY DESIGNS

References:
Southwest Museum.
Dorothy Smith Sides, collection of.

a Flower motif, Dorothy Smith Sides
b Circular design, Dorothy Smith Sides
c Flower motif, Dorothy Smith Sides
d Circular design, Southwest Museum

The pueblo of Sia is on the Jemez river, 16 miles from Bernalillo, New Mexico. Originally its population was very large; it has decreased, however, until at the present it is one of the poorest, with only 150 inhabitants. The Sia women make an excellent pottery which closely resembles the representative type of Acoma. The colors used are red and black on a cream slip and is very often decorated with plant and animal forms, especially birds.

The particular combination and arrangement which is found at Acoma occurs again and again at Sia. In fact, so similar are they that often it would be impossible to tell from the decoration alone whether a jar came from Acoma or Sia. However, the clay of Sia is coarse and heavy, while that of Acoma is extraordinarily light and fine.

PLATE 20

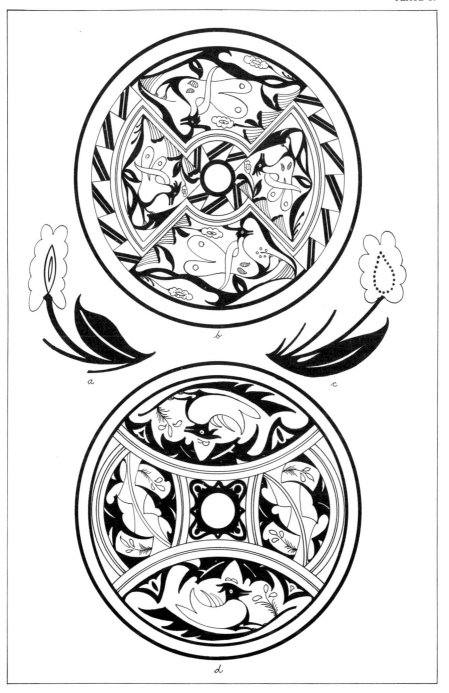

a

b

c

d

Plate 21

SAN ILDEFONSO, NEW MEXICO. PUEBLO GROUP
ANCIENT POLYCHROME PATTERNS

References:
Southwest Museum
Pueblo Pottery Making
Carl E. Guthe
The Rain-makers
Mary R. Coolidge
The Pueblo Potter
Ruth Bunzel
Pueblo Indian Painting
Hartley Burr Alexander
Pueblo Indian Pottery, vol. 1, 1933
Kenneth M. Chapman

a Plate 25, No. 7, Chapman
b Plate 25, No. 14, Chapman
c Plate 35, Guthe
d Plate 4, No. b, Guthe

San Ildefonso, an exceptionally interesting village of only about 100 inhabitants, is situated on the Rio Grande, not far from Santa Fe. The earthenware is of fine quality and exquisitely modeled, the beauty of a vessel depending upon the perfection of finish; ornament is merely to show by contrast the loveliness of the deep lustrous polish. The colors used in decorating the pottery are minerals, mostly ochres, with the exception of black, which comes from the guaco or Rocky Mountain bee plant.

With these people pottery is an important and profitable industry which has grown so steadily that its production has brought prosperity to the pueblo.

PLATE 21

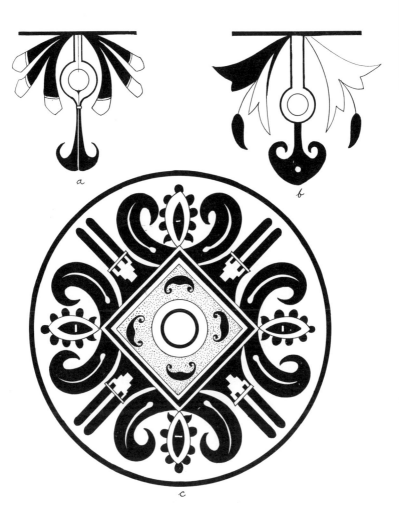

a

b

c

d

Plate 22

SAN ILDEFONSO, NEW MEXICO. PUEBLO GROUP
MODERN POLYCHROME, BLACK ON BLACK, RED ON RED WARE

References:
Southwest Museum
Pueblo Pottery Making
Carl E. Guthe
The Rain-makers
Mary R. Coolidge
The Pueblo Potter
Ruth Bunzel
Pueblo Indian Painting
Hartley Burr Alexander
Pueblo Indian Pottery, vol. 1, 1933
Kenneth M. Chapman
Introduction to American Indian Art, 1931
John Sloan and Oliver La Farge

a Southwest Museum
b Southwest Museum
c Southwest Museum
d Plate XVII, John Stone and Oliver La Farge

The outstanding feature of San Ildefonso design is its restraint and brevity of expression; line is very important, and, too, the potters expend infinite time and pains in the process of polishing. They have developed a great variety of forms and decorations; their ware consits of a polished red, black-and-red on a light slip, and a polished black with designs in dull black. On all bowls the decoration is executed within bands which show considerable variety based on a small number of motifs. The most frequent decoration is the repetition of a single unit. The perfection of each piece depends on the precision of the maker.

PLATE 22

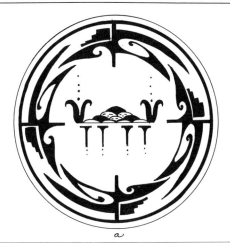

a

b

c

d

Plate 23

References:
Southwest Museum
Pueblo Pottery Making
Carl E. Guthe
The Rain-makers
Mary R. Coolidge
The Pueblo Potter
Ruth Bunzel
Collection of Mrs. Kenneth Worthen
Pueblo Indian Pottery, vol. 1, 1933
Kenneth M. Chapman

a Mrs. Kenneth Worthen, collection of
b Mrs. Kenneth Worthen, collection of
c Page 125, No. 17, appendix 3, plate XXXVI, Ruth Bunzel
d Page 125, No. 23, appendix 3, plate XXXVI, Ruth Bunzel
e Page 126, No. 28,appendix 3, plateXXXVIII,Ruth Bunzel

Although polished black ware has been typical of San Ildefonso pottery since early times, it was not until Maria Martínez and her husband Julian, discovered, in 1921, the method of applying designs in self color, that this type of modern ceramics came into existence. She fashions her jars and bowls with such art that she has lifted her product into a class by itself. Her pieces are always graceful in form, admirable in design, thin and well fired, and altogether stamped with a brilliance of artistry that commands one's highest admiration. The painting is done usually by Julian.

PLATE 23

a b

c

d

e

Plate 24

ACOMA, NEW MEXICO. PUEBLO GROUP
POTTERY DESIGNS

References:

Illustrated Catalogue of the Collections Obtained from
the Indians of New Mexico and Arizona in 1879.
James Stevenson,
Second Annual Report Bureau of Ethnology, 1883, pp.
307-465.
Introduction to American Indian Art
John Sloan and Oliver La Farge

a Fig. 618, No. 39581, James Stevenson
b Plate XVI, Ancient Acoma, John Sloan and Oliver
 LaFarge
c Fig. 619, No. 41316, James Stevenson

In western central New Mexico is the Pueblo of Acoma, "The City of the Sky,"
built 7000 feet above sea-level on a rocky mesa seventy acres in area with perpendicular
walls fifty-seven feet high. The pueblo is reached by precipitous clefts, up which all
material was carried to build the village. It is inhabited to-day and may be reached by
these same paths

Acoma was first visited by Spaniards in the year 1540. The story of the wars
fought on this mighty rock is so thrilling as to hold one spellbound.

Of all Indians, none are more resentful of intrusion than the people of Acoma, who
are unwilling to impart any real knowledge of themselves.

PLATE 24

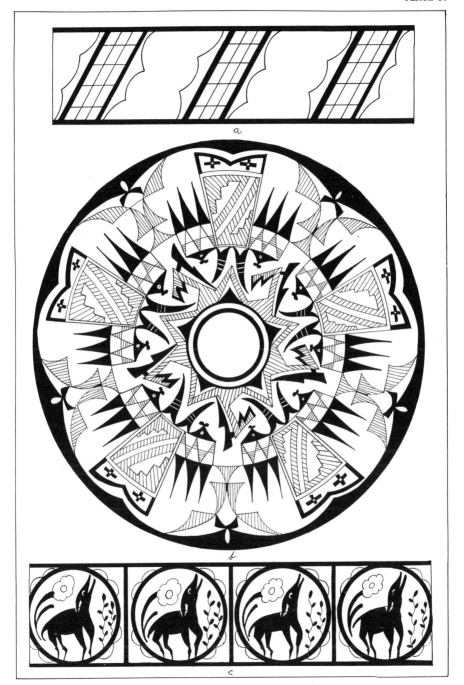

a

b

c

Plate 25

ACOMA, NEW MEXICO. PUEBLO GROUP
POTTERY DESIGNS

References:
Illustrated Catalogue of the Collection Obtained from
the Indians of New Mexico and Arizona in 1879.
James Stevenson,
Second Annual Report Bureau of Ethnology, 1883, pp.
307-465.
Southwest Museum

a Fig. 621, No. 41318, James Stevenson
b Southwest Museum
c Fig. 622, No. 42377, James Stevenson

In the pottery of Acoma one will find designs of trees, leaves, birds, and flowers, combined with geometric patterns; the colors used are black, red, and a creamy gray. The ware of Acoma is highly prized for its thinness and lightness, as well as for the wide range of its charming decoration.

The first delicate hair line around the top of a jar is never quite closed, the opening or space thus left is the "exit trail of life" through which the soul of the vessel may make its exit, for to the Indians every object is animate.

In addition to jars made for domestic use, there are vessels set aside for ceremonials. Sometimes funerary vessels were made solely for depositing with the dead.

PLATE 25

a

b

c

Plate 26

SANTO DOMINGO, NEW MEXICO. PUEBLO GROUP
POTTERY DESIGNS

References:
Southwest Museum
Pueblo Indian Pottery, vol. 1, 1933.
Kenneth M. Chapman

a Southwest Museum
b Southwest Museum
c Southwest Museum

The pueblo of Santo Domingo is on the east bank of the Rio Grande in north central New Mexico. It is the most conservative of the pueblos, and the people are very jealous of white interference in their affairs. Pottery is still made by the women, who form a heavy white ware with bold designs in black. The use of religious symbols for decoration is forbidden, and the breaking of this rule would be severely punished. Their vessels include large and small bowls, ollas, and huge storage jars, which serve occasionally as drums.

PLATE 26

a

b

c

Plate 27

SANTO DOMINGO, NEW MEXICO. PUEBLO GROUP
POTTERY DESIGNS

References:
Southwest Museum
Pueblo Indian Pottery, vol. 1, 1933.
Kenneth M. Chapman

a Southwest Museum
b Southwest Museum
c Southwest Museum
d Southwest Museum

Santa Domingo slip, when applied, does not need to be polished with a stone, as is necessary with much of the Pueblo pottery.

The decorative art of Santo Domingo had been held to a severely geometrical system until the beginning of the present century, when the use of red, and the elaboration of plant motifs, led to the notable enrichment of the ancient art. The sacred combination of cloud, lightning, and rain symbols is still tabu, and these, if used singly, are hidden in formal arrangements of geometric and other units.

The "path of the spirit" or "exit trail of life" is often bounded by parallel lines extending vertically from rim to base.

PLATE 27

a

b

c

d

Plate 28

Zuñi, New Mexico. Pueblo Group
Pottery Designs

References:
Illustrated Catalogue of the Collection Obtained from
the Indians of New Mexico and Arizona in 1879.
James Stevenson,
Second Annual Report Bureau of Ethnology, 1883, pp.
307-465.

a Fig. 367, No. 40317
b Fig. 362, No. 41150
c Fig. 363, No. 41158
d Fig. 360, No. 39916

The Zuñi, who once occupied six pueblos, which through misunderstanding
were called the "Seven Cities of Cibola," now live in a single permanent village and
three summer pueblos on the Zuñi River in western New Mexico. They are a highly
developed people, both physically and mentally. From early times they were not only
skilled architects, but accomplished potters, weavers, and farmers, raising their crops
both by dry-farming and by irrigation.

Their ceremonies, elaborate and numerous, are often performed by masked per-
sonages who wear highly colored costumes replete with symbolism.

PLATE 28

a

b

c

d

Plate 29

Zuñi, New Mexico. Pueblo Group
Pottery Designs

References:
Illustrated Catalogue of the Collection Obtained from
the Indians of New Mexico and Arizona in 1879.
James Stevenson,
Second Annual Report Bureau of Ethnology, 1883, pp.
307-465.

a Fig. 427, No. 40290
b Fig. 361, No. 39934, bird form
c Fig. 428, No. 39954, leaf and butterfly ornament
d Fig. 363, No. 41158, bird form
e Fig. 361, No. 39934, Helix freely used
f Fig. 363, No. 41158

Zuñi designs are conspicuous for their simplicity, balance, rhythm, abstraction, surpassing range of elements, and virility. These designs, which are of a type that has a recognized value of its own; consist chiefly of triangular figures, open circles, diamonds, scrolls, and arches. The pottery designs are usually divided into zones, and there is a rare combination of patterns; one never finds a meander or Greek fret, and there is a complete absence of vines and floral devices, except that on many of the water jars appear a conventionalized sunflower.

The colors employed in Zuñi pottery ornamentation are cream for the background, with black, red, and brown for the patterns.

PLATE 29

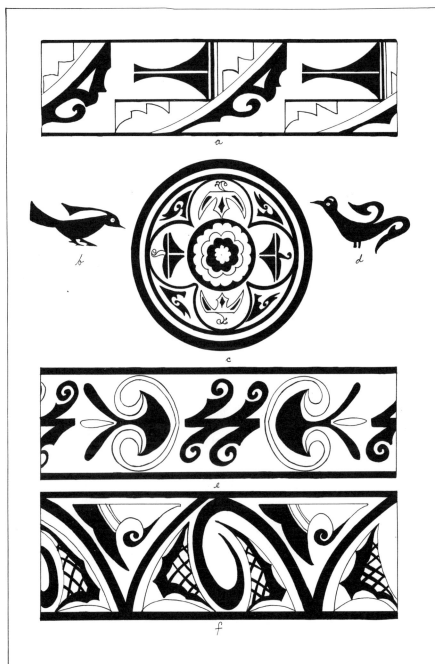

a

b

c

d

e

f

Plate 30

Zuñi, New Mexico. Pueblo Group
Pottery Designs

References:
Illustrated Catalogue of the Collection Obtained from
the Indians of New Mexico and Arizona in 1879.
James Stevenson,
Second Annual Report Bureau of Ethnology, 1883, pp.
307-465.

a Fig. 361, No. 39934, decoration belongs to third var-
 iety of design.
b Fig. 401, No. 40486, outside bowl design
c Fig. 362, No. 41150, bird form
d Fig. 360, No. 39916, Helix
e Fig. 365, No. 40312, bird form
f Fig. 365, No. 40312
g Fig. 362, No. 41150

Notwithstanding the oppression of the Spaniards in early times, the culture and
esthetic ability of the Zuñis flourished unabated, and they are still producing excellent
examples of their craft.

The colors of the Zuñis have a distinct significance. North is designated as
yellow, because the light of morning and evening in winter is yellow; West is blue,
for westward is the Pacific Ocean; South is red, it being the region of summer, and
the East is designated as white, to signify dawn. The upper region is multicolored,
as the light of the sun on clouds; the nether region, black, as deep caverns and
springs.

PLATE 30

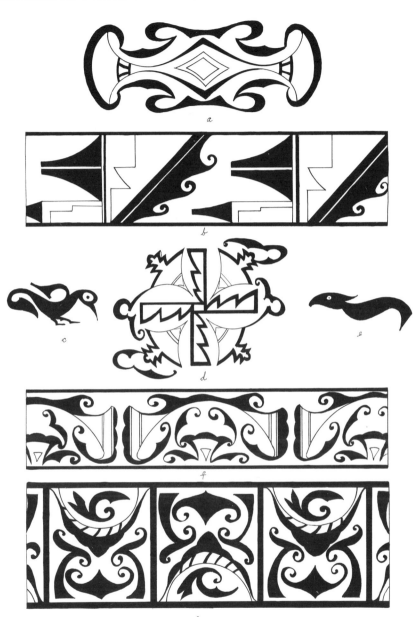

Plate 31

Laguna, New Mexico. Pueblo Group Pottery Designs

References:

Illustrated Catalogue of the Collection Obtained from the Indians of New Mexico and Arizona in 1879. James Stevenson, Second Annual Report Bureau of Ethnology, 1883, pp. 307-465.

a Fig. 585, No. 41295, broad oblique stripes and a figure resembling blades of corn.

b Fig. 616, No. 41297, little similarity to any other decoration it contains a scroll and abstract figures.

c Fig. 588, No. 42386,large flower ornaments surrounding birds with a crest, and serrated figures. One bird represents a raven, the other a California quail.

d Fig. 587, No. 42381, leaves designed to represent corn blades, partially symbolical.

Laguna, the largest of all the Pueblo settlements east of the Continental Divide, is situated on the south bank of the San José river, forty-five miles west of Albuquerque, New Mexico. It is made up of a central pueblo, with a number of smaller ones. The Lagunas are of exceptional intellect and physical development.

The Laguna dwellings are chiefly two-story adobe structures, architecturally superior in point of construction to those of many Pueblos.

PLATE 31

a

b

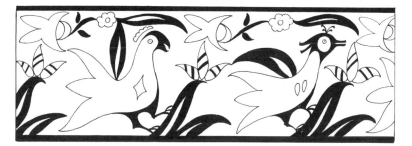

c

d

Plate 32

LAGUNA, NEW MEXICO. PUEBLO GROUP
POTTERY DESIGNS

References:
Illustrated Catalogue of the Collection Obtained from the Indians of New Mexico and Arizona in 1879.
James Stevenson,
Second Annual Report Bureau of Ethnology, 1883, pp. 307-465.

a Fig. 613, No. 42473, symbolical leaf design.
b Fig. 615, No. 42471, circular and leaf designs.
c Fig. 610, No. 42380, oblique bars extending from a center diamond.
d Fig. 586, No. 42385, undulating bands and triangles in alternate enclosed and upper space.
e Fig. 592, No. 41298, well formed design with no interest.

The Laguna men are engaged in agriculture and stock raising, while the women, in common with all other Pueblo tribes, are the potters. They produce a variety of exquisite vessels with designs of flowers and bird forms in red and black on a white ground. The pottery is beautifully made, exceptionally well designed, and symmetrically executed.

PLATE 32

a

b

c

d

e

Plate 33

COCHITI, NEW MEXICO. PUEBLO GROUP
POTTERY DESIGNS

References:
Illustrated Catalogue of the Collection Obtained from
the Indians of New Mexico and Arizona in 1879.
James Stevenson,
Second Annual Report Bureau of Ethnology, 1883, pp.
307-465.
Introduction to American Indian Arts, 1931,
John Sloan and Oliver La Farge
The Rain-makers
Mary R. Coolidge

a Fig. 39733, No. 623, James Stevenson.
b Southwest Museum
c Fig. 39717, No. 631, James Stevenson.
d Fig. 39726, No. 638, James Stevenson.
e Fig. 39718, No. 633, James Stevenson.
f John Sloan and Oliver La Farge.
g Fig. 39733, No. 623, James Stevenson.
h Fig. 39562, No. 640, James Stevenson.
i Fig. 39726, No. 638, James Stevenson.

Cochiti is on the west side of the Rio Grande, twenty-five miles southwest of
Santa Fe. Although now of small population, the people of this pueblo claim the
ruined towns to the north of their village as the homes of their ancestors. While
sharing in the revival of the Pueblo arts and crafts, the ancient symbolism and
ceremonies of Cochiti are well preserved.

The pottery designs designate rain, fruition symbols, birds, and flowers, which
are arranged with little rhythmic repetition, being scattered over the surface. The
pottery, which was formerly black-on-white, now shows some red in the decoration.

PLATE 33

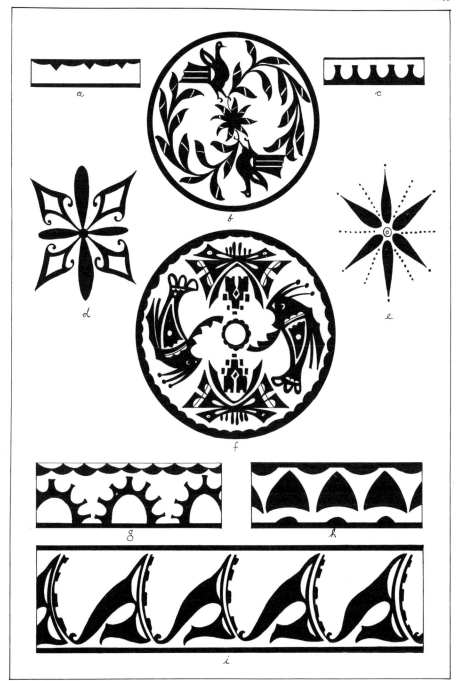

Plate 34

WALPI, ARIZONA. PUEBLO GROUP
POTTERY DESIGNS

Reference:

Illustrated Catalogue of the Collection Obtained from
the Indians of New Mexico and Arizona in 1879.
James Stevenson,
Second Annual Report Bureau of Ethnology, 1883, pp.
307-465.

a Fig. 514, No. 41609
b Fig. 531, No. 41391
c Fig. 518, No. 41363
d Fig. 518, No. 41363
e Fig. 532, No. 41390
f Fig. 519, No. 41366
g Fig. 514, No. 41609
h Fig. 514, No. 41609

The pueblo of Walpi is situated on the First Mesa of Hopiland in Arizona, on one side of which are three rows of terraced houses, and on the other a precipice. A snake dance, the culmination of a nine-day ceremony for rain, is performed in mid-summer of every alternate year.

The Hopi of Walpi have developed an exceptionally beautiful type of pottery, of which there are all too few examples extant. They produced a white decorated ware similar to that of the Zuñi, using triangular figures, curved line designs and birds.

Commencing about the year 1895, Nampeyo, a woman of the pueblo of Hano, has practically revolutionized the decoration of Hopi pottery by introducing adaptations of the designs on prehistoric Hopi earthenware.

PLATE 34

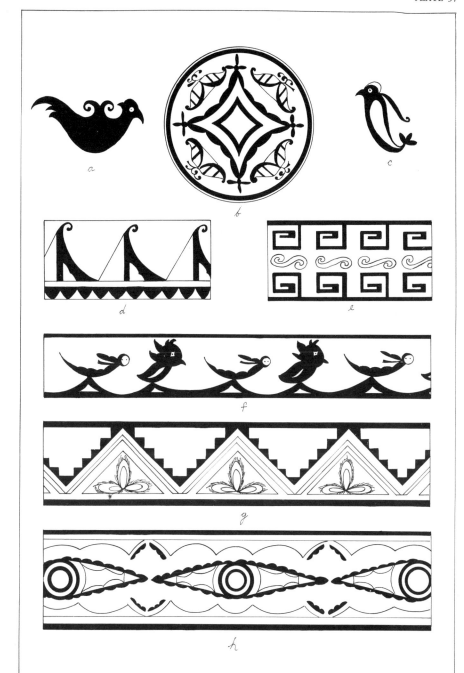

a

b

c

d

e

f

g

h

Plate 35

MODERN HOPI, ARIZONA. PUEBLO GROUP
POTTERY DESIGNS

References:
Pueblo Pottery Making
Carl E. Guthe
The Rain-makers
Mary R. Coolidge
The Pueblo Potter
Ruth Bunzel

a Page 119, No. 14, appendix 2, plate XXXIV, Ruth Bunzel
b Page 118, No. 1, appendix 2, plate XXXIII, Ruth Bunzel
c Page 118, No. 5, appendix 2, plate XXXIII, Ruth Bunzel
d Page 118, No. 2, appendix 2, plate XXXIII, Ruth Bunzel
e Page 119, No. 15, appendix 2, plate XXXIV, Ruth Bunzel

The period of modern Hopi design goes back to about 1850, that is, the period of intimate contact with civilization. The artists are entirely unconscious of the principles of design in their work, and with no guide except perception of form, they produce an accurately finished vessel. A young girl, when given instruction, is told, "Paint anything you like, only put it on straight." The potter is not influenced by the meaning of her design, except in the use of symbols on pottery designed for ceremonial use. Originality and individuality are general with all potters, and she paints to please herself only, although she may be influenced by the prevailing fashion.

PLATE 35

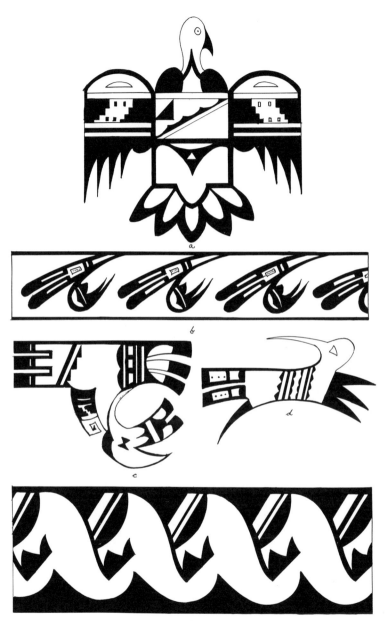

Plate 36

MODERN HOPI, ARIZONA. PUEBLO GROUP
POTTERY DESIGNS

References:
 Pueblo Pottery Making
 Carl E. Guthe
 The Rain-makers
 Mary R. Coolidge
 The Pueblo Potter
 Ruth Bunzel

a Page 119, No. 17, appendix 2, plate XXXIV, Ruth Bunzel
b Page 118, No. 3, appendix 2, plate XXXIII, Ruth Bunzel
c Page 118, No. 1, appendix 2, plate XXXIII, Ruth Bunzel
d Page 119, No. 18, appendix 2, plate XXXIV, Ruth Bunzel
e Page 39 b, plate XV, Ruth Bunzel

The present mode of Hopi pottery is a renewal of the ancient type illustrated by Sikyatki ware. In the jars of this modern ware the decoration is principally on the upper part, but extends over the surface to just below the shoulder. The design is bordered at the inner edge by a broad black band, with a similar band at the outer edge. Within a few years this new style has completely displaced the old types of ware, due to a love for the ancient and more pleasing symbolic patterns adapted by Nampeyo, as before mentioned.

PLATE 36

a

b

c

d

e

Plate 37

Zuñi, NEW MEXICO
DANCE MASKS

Reference:
The Zuñi Indians: their Mythology, Esoteric Fraternities, and Ceremonies.
Matilda Coxe Stevenson,
Twenty-third Annual Report Bureau of American Ethnology, 1904, pp. 3-608.

a Plate LIV, Mask of Sáyatäsha
b Plate LXXIV, Mask of Hémishikwe
c Plate LXX, Mask of Úwanami
d Plate LVa, Mask of Yámuhakto
e Plate XLIIIb, Mask of Shíwani

The Zuñi have preserved their strong individuality by extreme exclusiveness, and by so doing may claim their high position. They have developed a philosophy which has been profoundly influenced by their environment and upon which is built a highly complicated ceremonial system which has as its object the tribal welfare and success in all undertakings. Their sacred personages, of whom there are very many, are represented in ceremony by performers who wear decorated masks and are elaborately costumed. The masks are usually of leather highly ornamented with symbolic devices.

PLATE 37

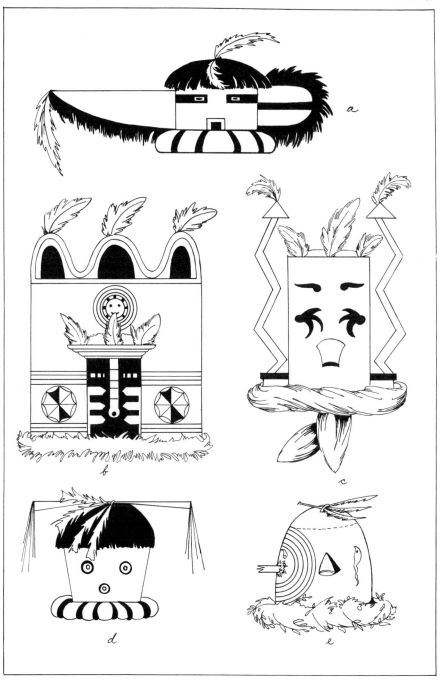

a

b

c

d

e

Plate 38

MARICOPA, ARIZONA
POTTERY, BASKETRY, WEAVING

References:
Yuman Tribes of the Gila River
 Leslie Spier
The North American Indian, vol. II, 1908, pp. 81-88.
Southwest Museum.

a Page 109, plate VIIh, Leslie Spier
b Southwest Museum
c Southwest Museum
d Page 317, fig. 13a, Leslie Spier
e Page 109, Fig. 7c, Leslie Spier
f Page 109, plate VIIf, Leslie Spier
g Page 109, fig. 7e, Leslie Spier

The Maricopa, a small tribe of the Yuman family, reside in southern Arizona not far from Phoenix. They have developed an interesting type of basketry and pottery designs, but borrowed their method of weaving from the Pimas. For their basketry it was customary to use the tisal willow, squaw-weed, root of the tule, and martynia, or devil's claw; leaves of the yucca being used as a filler for the inner coil. The one tool that is always used in basket making is a bone awl, which at death is buried with the artisan.

The designs are striking and varied, the fret being used in combination with circular forms of the swastika. As their artistic faculty developed, practice brought increased skill, and some examples of their baskets, pottery, and weaving are exquisitely beautiful.

PLATE 38

a

b

c

d

e

f

g

Plate 39

References:
Aboriginal American Basketry: Studies in a Textile Art
without Machinery.
Otis Tufton Mason,
Annual Report of the U. S. National Museum for 1902,
pp. 171-548.
Indian Basketry,
George Wharton James

a Southwest Museum, pottery design
b Southwest Museum, beadwork
c Southwest Museum, beadwork
d Southwest Museum, beadwork
e Southwest Museum, beadwork

The Mohave, who gave name to that vast arid waste, the Mohave Desert, are
of Yuman stock, like the Maricopas, who have lived for centuries in the valley of the
Rio Colorado in California and Arizona. In early times the Mohave were a powerful
tribe, but owing to outside influences they have become greatly diminished in number.

The beadwork made by the women is interesting in design; the patterns are
made up of so-called symbols combined in various ways. The meaning of these de-
signs is not fixed, so the same symbols are often given different meanings even by
persons within the tribe. The Indian artists picture in their work the common objects
of everyday life; the great powers of nature, the sun, moon, stars, wind, trees, animals,
birds, or whatever might suit their fancy. On clothing, designs were sometimes used
that were supposed to have power to protect the wearer from harm. Many of the
designs are worked on a white background representing the snow-time, or winter,
which was the season when the men went on the war trail to achieve honors and
glory. Other colors symbolic of military achievement were red, indicating wounds
inflicted or received; yellow the sun-colored war horses, and green, representing the
grass or summer. In religious or ceremonial designs, red represents the sunset or thun-
der; blue, the sky, water or day; yellow, the dawn or sunlight; and black, the night.

PLATE 39

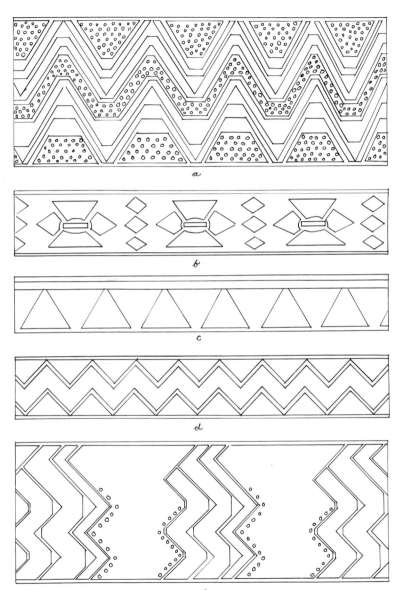

a

b

c

d

e

Plate 40

SAN CARLOS, ARIZONA AND MESCALERO APACHE, NEW MEXICO
BASKET DESIGNS

References:
Basketry of the San Carlos Apache
Helen H. Roberts,
Anthropological Papers of the American Museum of
Natural History, 1929, vol. XXXI, pt. 3.
Illustrated History of Baskets and Plates, made by Cali-
fornia Indians and many other tribes.
T. A. Roseberry collection

a Page 198, fig. 27, Helen H. Roberts
b Page 198, fig. 27, Helen H. Roberts
c Page 183, fig. 22b, Helen H. Roberts
d Page 178, fig. 19g, Helen H. Roberts
e Plate 18, T. A. Roseberry collection

A small band of people numbering 1172, the San Carlos Apache, live along the
main stream and nearer branches of the Gila River to the east of Phoenix, Arizona.

The San Carlos Apache do not use grass in their baskets, but only the shoots of
shrubs and young trees, which accounts for the rigidity of their product. Occasionally
modern baskets display a touch of red in the color scheme of black and cream, with
delightful effect. The material which furnishes the red is the root of the yucca.

These people make three distinct types of baskets: water-jars, carrying baskets,
and food bowls of every kind. The bowls are for holding meal, winnowing grain,
parching corn, boiling food, mashing berries, mixing dough, and laundry purposes;
in fact a bowl or tray is needed by the Indian woman in much the same way as by her
white sister. Their twined basketry is crude in texture in design, and in the colors
used for the designs. On the other hand, their coiled baskets show the handiwork
of an art-loving people. The designs are checkerwork, zigzag, triangles, and diamonds
with diagonal, vertical, or horizontal lines. The introduction of human or animal
figures, sometimes grotesque, is of comparatively recent origin. The square and
rectangle are entirely absent as separate figures, occuring only in some sort of checker
formation. Triangles and diamonds are worked in solid colors, usually black, since the
background is cream. The adaptation of the size of design to the form of the back-
ground field illustrates clearly that the San Carlos artistic sense is of an unusually
high order.

PLATE 40

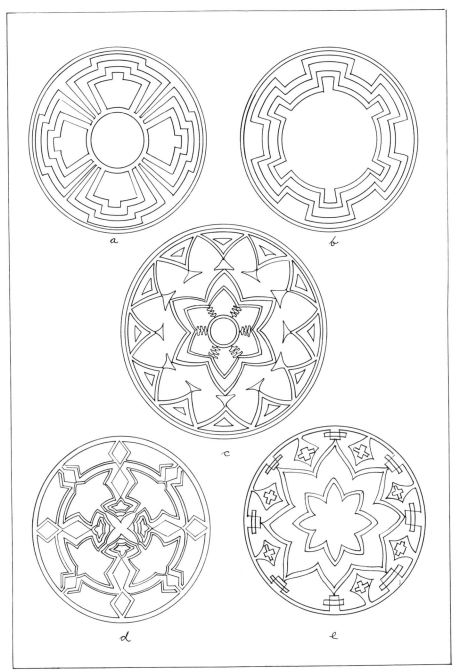

a

b

c

d

e

Plate 41

References:

A Study of the Textile Art in its Relation to the Development of Form and Color.
William H. Holmes,
Sixth Annual Report Bureau of Ethnology, 1888, pp. 189-252.
Annual Report of the Smithsonian Institution, 1928.
Specimens from Southwest Museum.
Indian Basketry,
George Wharton James

a Southwest Museum
b Southwest Museum
c Plate 17, Report Smithsonian Institution, 1928
d Page 223, fig. 325, William H. Holmes
e Southwest Museum
f Southwest Museum

The Apache are to be found in New Mexico and Arizona. A warlike nomadic people, the terror of the early white settlers of the Southwest, yet when intelligently treated, no more appreciative or tractable Indians are to be found.

The Apache are expert basket-makers, proud of the fineness of their work, extremely poetic in the designs they conceive, and artistic in their arrangement. The designs usually consist of small figures with a sense of ease approaching realism.

PLATE 41

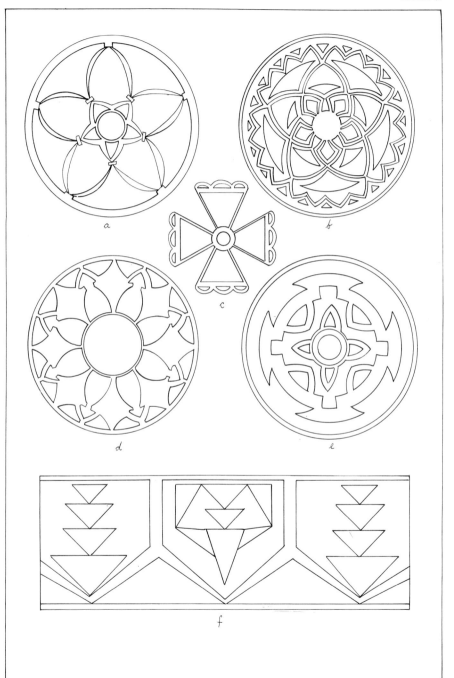

a

b

c

d

e

f

Plate 42

PAPAGO, ARIZONA-SONORA
POTTERY DESIGNS

References:
Basketry of the Papago and Pima,
Mary L. Kissell,
Anthropological Papers of the American Museum of
Natural History, 1916, vol. XVII, pp. 115-264.

a Page 213, fig. 59e
b Page 213, fig. 59f
c Page 218, fig. 64b
d Page 219, fig. 65c
e Page 239, fig. 77
f Page 240, fig. 78

The Papago live in southern Arizona and northwestern Sonora. Possibly in no other spot in North America has the Indian been less influenced by white men, so that old customs persist, even to the tattooing of the face by older men and women.

Like all desert regions, plant growth was hindered in its struggle for existence, and the desert vegetation exerted an influence upon the activities of the tribes, and the tribes in turn have adapted themselves to the limitations of the desert, hence much effort and skill were required to discover the materials most suitable for basket-making. Excellent coiled baskets have been produced by Papago women, but it is said that many of them have been sacrificed by burning on the death of the owners.

PLATE 42

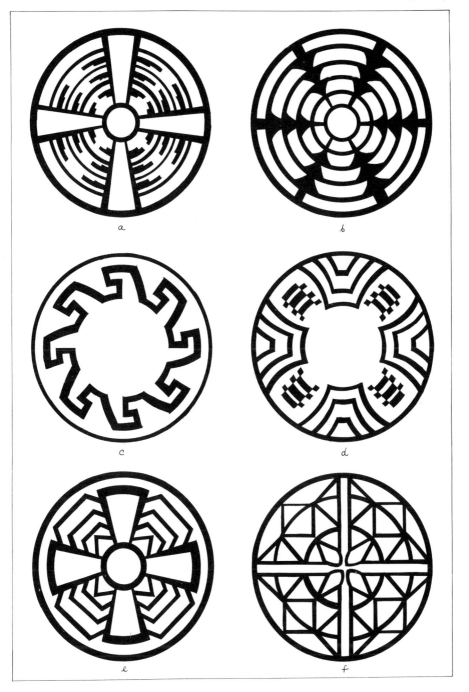

a

b

c

d

e

f

Plate 43

PAPAGO, ARIZONA-SONORA
POTTERY DESIGNS

References:
Basketry of the Papago and Pima,
Mary L. Kissell,
Anthropological Papers of the American Museum of
Natural History, 1916, vol. XVII, pp. 115-264.

a Page 221, fig. 67d
b Page 223, fig. 69
c Page 221, fig. 67c
d Page 213, fig. 59b
e Page 239, fig. 77
f Page 216, fig. 62c

Distinctive differences between the basketry designs of the Pima and the Papago are found. The influence of the environment is felt, since the supply of martynia gives Papago a dominance of dark over light in their baskets. Aside from the dissimilarity in dark and light, the bands differ obviously in shape, proportion, and general contour. One is impressed by the strong feeling for large masses of dark and light in comparison to the feeling for line of the Pima. The Papago woman deals mostly with a horizontal line in her work, which gives a restful quality to the design. They have a distinct number of typical designs, namely, the encircling fret, the horizontal band arranged in a variety of ways, and the vertical fret.

Papago design is dignified and reserved, handled in a simple, strong, and direct manner.

PLATE 43

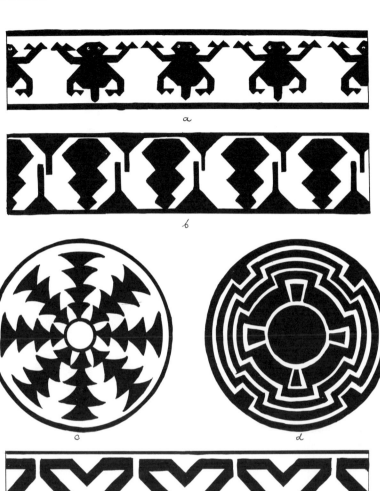

a

b

c d

e

f

Plate 44

PIMA, ARIZONA
BASKET AND POTTERY DESIGNS

Reference:
The Pima Indians
Frank Russell,
Twenty-sixth Annual Report Bureau of American Ethnology, 1908, pp. 3-389.
a Plate XXVII, d
b Plate XXVIII, a
c Plate XXV, a
d Plate XXVII, e
e Plate XVIII, c
f Plate XIX, f

The Pima inhabit a reservation in southern Arizona not far from Phoenix, and have always been noted for their quiet and peaceful character. They have developed a high type of basketry which contains some intricate patterns that resemble Greek and Oriental figures; in the variations of the swastika alone they show splendid examples. Many of their designs represent the source of water supply in the center, with radiating geometric lines representing the winding streams.

In the construction of their baskets the Pima use the tisal willow, squaw weed, skunk weed, the root of the tule, and martyina, or devil's claw.

PLATE 44

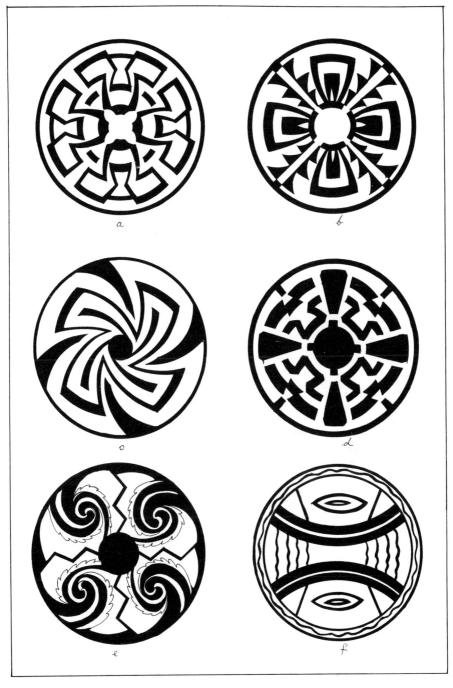

a

b

c

d

e

f

Plate 45

PIMA, ARIZONA
BASKETRY DESIGNS

Reference:
The Pima Indians
Frank Russell,
Twenty-sixth Annual Report Bureau of American Ethnology, 1908, pp 3, 390.

a Plate XXXII, c
b Plate XXX, h
c Plate XXIX, c
d Plate XX, e
e Plate XXXI, f
f Page 130, fig. 55

In Pima basketry there is a dominance of light over dark color, with a feeling for line which is expressed in a network of black. Horizontal lines are used in a secondary way, being held in subservience to a more dominant motif, the spiral and whorl. The patterns are the fret, rectangular whorl, triangular whorl, spiral rosette, and terrace. The fret is the oldest and most common design. The whorl consists of four central twirling rectangular arms with a repeating whorl at the rim. Obliques are frequently composed of a line of small triangles forming a terraced design.

Pima work is replete with action and grace; it is elaborate, delicate, and intricate; the technique is clear-cut and perfect in craftsmanship.

PLATE 45

a

b

c

d

e

f

Plate 46

CHEMEHUEVI, ARIZONA-CALIFORNIA
BASKET DESIGNS

References:
Aboriginal American Basketry: Studies in a Textile Art without Machinery.
Otis Tufton Mason,
Annual Report of the U. S. National Museum for 1902, pp. 171-548.
Basketry of the San Carlos Apache
Helen H. Roberts,
Anthropological Papers of the American Museum of Natural History, 1929, vol. XXXI, pt. 3.

a Plate 231, vol. 2, Otis Tufton Mason
b Plate 231, vol. 2, Otis Tufton Mason
c Page 180, fig. 21, Helen H. Roberts
d Page 179, fig. 20, Helen H. Roberts
e Plate 231, Otis Tufton Mason
f Plate 231, Otis Tufton Mason

The Chemehuevi live along the Colorado river north of the Mohave. They produce basketry similar to that of the San Carlos Apache, hence there is a tendency to confuse the two.

Horizontal arrangements are typical, while radiating or whorling distributions are rare. This difference in design arrangement is one of the distinguishing features of the basketry of the Chemehuevi and Apache, also the finish of the rim coil; were it not for this it would be difficult to discriminate the products of the two tribes. Hence it is more by feel, which comes only with study, than by rule that the basket lover may learn to recognize the work of the various Indians.

PLATE 46

a

b

c

d

e

f

Plate 47

References:

The Navaho and his Blanket
U. S. Hollister
Navaho Weaving
Charles Avery Amsden
Design detail from blankets, Southwest Museum
Design detail from blankets, Mrs. Kenneth Worthen
Design detail from blankets, Mrs. F. R. Smith

a Mrs. Kenneth Worthen
b Southwest Museum
c Mrs. Kenneth Worthen
d Southwest Museum
e Southwest Museum
f Mrs. F. R. Smith
g Mrs. F. R. Smith
h Mrs. Kenneth Worthen
i Southwest Museum
j Mrs. F. R. Smith

The Navaho are a semi-nomadic Athapascan tribe occupying a reservation in northern Arizona, northwest New Mexico, and southern Utah. Numbering about 40,000, they are the most populous tribe in the United States.

They are a picturesque people whose principal interests are blanket weaving, sheep herding, and the manufacture of silver and turquoise jewelry. The Navaho shear their sheep, wash, dye, card, spin, and weave the wool into attractive and valuable blankets. The primitive art of weaving is many centuries old, but so far as known the Navaho acquired the art from captive Pueblo women not earlier than the latter part of the eighteenth century.

PLATE 47

Plate 48

Sand to the depth of two inches is spread on the floor, then smoothed and evened with a curved stick; on this sand the artist works from the center outward with colors made by a man sitting at the east. Yellow, red, and white are made by grinding native rocks; black is made from charcoal. Black and white are mixed to produce a gray-blue.

The four sacred colors of the cardinal points are, white for the East, blue for the West, yellow for the South, and black for the North.

The artist then takes a pinch of the desired color between his thumb and forefinger and lets it trickle in the line of his proposed design, when the pattern is finished, with its exquisite color and detail, a rare work of art is produced.

PLATE 48

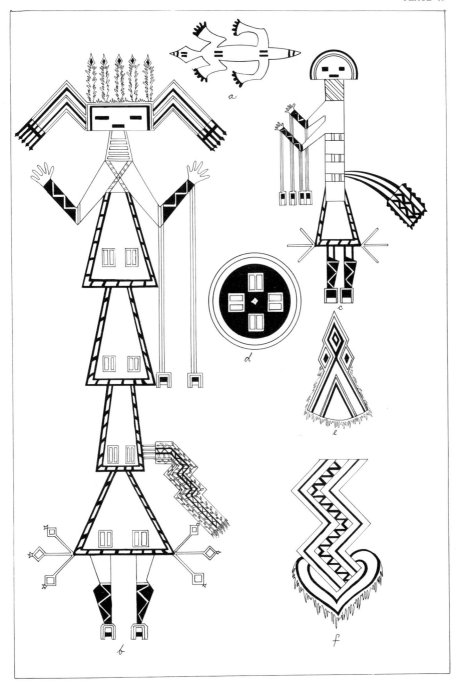

Plate 49

NAVAHO, ARIZONA-NEW MEXICO. NOMADIC GROUP
PATTERNS AND FIGURES FROM DRY PAINTINGS OF DŚILYIDJE-QÁCAL.

Reference:
The Mountain Chant.
Fifth Annual Report Bureau of Ethnology, 1887, pp.
379-467.

a Plate XVII
b Plate XVII
c Plate XVII
d Plate XVII
e Plate XVII
f Plate XVII
g Plate XVII
h Plate XVII
i Plate XVIII

Every ceremony has its own dry painting, and these represent a very old traditional art which was borrowed from the Pueblos. The essence of Navaho art is an arrangement and repetition of a few elements, either in stripes or around a central motif, or spotting against a plain or striped background. The keynote of their work is a large mass of perfect simplicity, and continuous repetition of quiet inert design.

PLATE 49

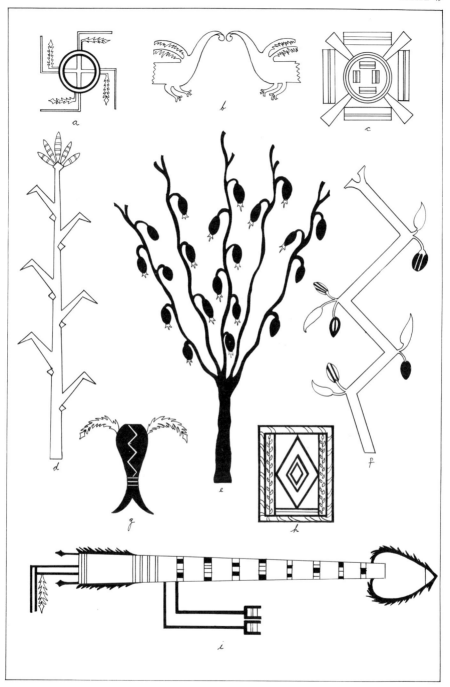

Plate 50

NAVAHO, ARIZONA-NEW MEXICO. NOMADIC GROUP
ANCIENT AND MODERN RUG DESIGNS

References:
Navaho Weavers and their Work.
Washington Matthews,
Third Annual Report Bureau of Ethnology, 1884, pp. 371-391.
Design detail from blankets, Southwest Museum.
Design detail from blanket, collection of Mrs. Kenneth Worthen.

a Southwest Museum
b Southwest Museum
c Southwest Museum
d Mrs. Kenneth Worthen
e Southwest Museum
f Southwest Museum

The women who have controlled the weaving industry for two centuries originally had only three natural colors to use, a rusty black, white, and a brownish gray; herbs and a desert brush were used to produce livlier shades. To intensify the black a dye was made of sumac, ochre, and piñon boiled together. Similarly was invented a dark blue, several shades of yellow, and a reddish color.

The women who for generations have been weaving from their imagination follow no visible pattern, yet the design, color, and proportion in the hands of an experienced weaver come out nearly perfect.

PLATE 50

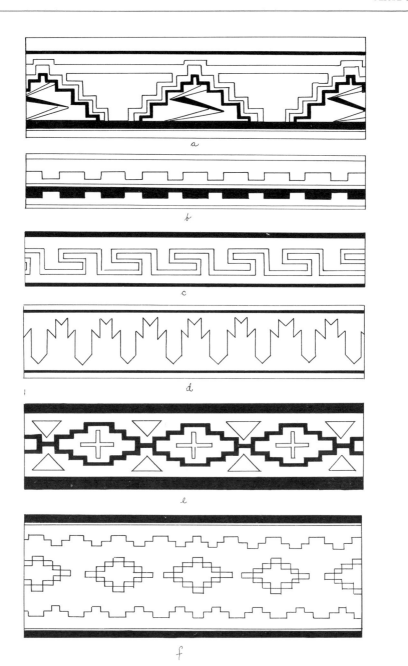

A CATALOG OF SELECTED
DOVER BOOKS
IN ALL FIELDS OF INTEREST

A CATALOG OF SELECTED
DOVER BOOKS
IN ALL FIELDS OF INTEREST

DRAWINGS OF REMBRANDT, edited by Seymour Slive. Updated Lippmann, Hofstede de Groot edition, with definitive scholarly apparatus. All portraits, biblical sketches, landscapes, nudes. Oriental figures, classical studies, together with selection of work by followers. 550 illustrations. Total of 630pp. 9⅛ × 12¼.
21485-0, 21486-9 Pa., Two-vol. set $29.90

GHOST AND HORROR STORIES OF AMBROSE BIERCE, Ambrose Bierce. 24 tales vividly imagined, strangely prophetic, and decades ahead of their time in technical skill: "The Damned Thing," "An Inhabitant of Carcosa," "The Eyes of the Panther," "Moxon's Master," and 20 more. 199pp. 5⅜ × 8½. 20767-6 Pa. $4.95

ETHICAL WRITINGS OF MAIMONIDES, Maimonides. Most significant ethical works of great medieval sage, newly translated for utmost precision, readability. Laws Concerning Character Traits, Eight Chapters, more. 192pp. 5⅜ × 8½.
24522-5 Pa. $4.50

THE EXPLORATION OF THE COLORADO RIVER AND ITS CANYONS, J. W. Powell. Full text of Powell's 1,000-mile expedition down the fabled Colorado in 1869. Superb account of terrain, geology, vegetation, Indians, famine, mutiny, treacherous rapids, mighty canyons, during exploration of last unknown part of continental U.S. 400pp. 5⅜ × 8½. 20094-9 Pa. $7.95

HISTORY OF PHILOSOPHY, Julián Marías. Clearest one-volume history on the market. Every major philosopher and dozens of others, to Existentialism and later. 505pp. 5⅜ × 8½. 21739-6 Pa. $9.95

ALL ABOUT LIGHTNING, Martin A. Uman. Highly readable nontechnical survey of nature and causes of lightning, thunderstorms, ball lightning, St. Elmo's Fire, much more. Illustrated. 192pp. 5⅜ × 8½. 25237-X Pa. $5.95

SAILING ALONE AROUND THE WORLD, Captain Joshua Slocum. First man to sail around the world, alone, in small boat. One of great feats of seamanship told in delightful manner. 67 illustrations. 294pp. 5⅜ × 8½. 20326-3 Pa. $4.95

LETTERS AND NOTES ON THE MANNERS, CUSTOMS AND CONDITIONS OF THE NORTH AMERICAN INDIANS, George Catlin. Classic account of life among Plains Indians: ceremonies, hunt, warfare, etc. 312 plates. 572pp. of text. 6⅛ × 9¼. 22118-0, 22119-9, Pa., Two-vol. set $17.90

ALASKA: The Harriman Expedition, 1899, John Burroughs, John Muir, et al. Informative, engrossing accounts of two-month, 9,000-mile expedition. Native peoples, wildlife, forests, geography, salmon industry, glaciers, more. Profusely illustrated. 240 black-and-white line drawings. 124 black-and-white photographs. 3 maps. Index. 576pp. 5⅜ × 8½. 25109-8 Pa. $11.95

ILLUSTRATED DICTIONARY OF HISTORIC ARCHITECTURE, edited by Cyril M. Harris. Extraordinary compendium of clear, concise definitions for over 5,000 important architectural terms complemented by over 2,000 line drawings. Covers full spectrum of architecture from ancient ruins to 20th-century Modernism. Preface. 592pp. 7½ × 9⅝. 24444-X Pa. $15.95

THE NIGHT BEFORE CHRISTMAS, Clement C. Moore. Full text, and woodcuts from original 1848 book. Also critical, historical material. 19 illustrations. 40pp. 4⅝ × 6. 22797-9 Pa. $2.50

THE LESSON OF JAPANESE ARCHITECTURE: 165 Photographs, Jiro Harada. Memorable gallery of 165 photographs taken in the 1930s of exquisite Japanese homes of the well-to-do and historic buildings. 13 line diagrams. 192pp. 8⅜ × 11¼. 24778-3 Pa. $10.95

THE AUTOBIOGRAPHY OF CHARLES DARWIN AND SELECTED LET-TERS, edited by Francis Darwin. The fascinating life of eccentric genius composed of an intimate memoir by Darwin (intended for his children); commentary by his son, Francis; hundreds of fragments from notebooks, journals, papers; and letters to and from Lyell, Hooker, Huxley, Wallace and Henslow. xi + 365pp. 5⅜ × 8. 20479-0 Pa. $6.95

WONDERS OF THE SKY: Observing Rainbows, Comets, Eclipses, the Stars and Other Phenomena, Fred Schaaf. Charming, easy-to-read poetic guide to all manner of celestial events visible to the naked eye. Mock suns, glories, Belt of Venus, more. Illustrated. 299pp. 5¼ × 8¼. 24402-4 Pa. $8.95

BURNHAM'S CELESTIAL HANDBOOK, Robert Burnham, Jr. Thorough guide to the stars beyond our solar system. Exhaustive treatment. Alphabetical by constellation: Andromeda to Cetus in Vol. 1; Chamaeleon to Orion in Vol. 2; and Pavo to Vulpecula in Vol. 3. Hundreds of illustrations. Index in Vol. 3. 2,000pp. 6⅛ × 9¼. 23567-X, 23568-8, 23673-0 Pa., Three-vol. set $41.85

STAR NAMES: Their Lore and Meaning, Richard Hinckley Allen. Fascinating history of names various cultures have given to constellations and literary and folkloristic uses that have been made of stars. Indexes to subjects. Arabic and Greek names. Biblical references. Bibliography. 563pp. 5⅜ × 8½. 21079-0 Pa. $8.95

THIRTY YEARS THAT SHOOK PHYSICS: The Story of Quantum Theory, George Gamow. Lucid, accessible introduction to influential theory of energy and matter. Careful explanations of Dirac's anti-particles, Bohr's model of the atom, much more. 12 plates. Numerous drawings. 240pp. 5⅜ × 8½. 24895-X Pa. $6.95

CHINESE DOMESTIC FURNITURE IN PHOTOGRAPHS AND MEASURED DRAWINGS, Gustav Ecke. A rare volume, now affordably priced for antique collectors, furniture buffs and art historians. Detailed review of styles ranging from early Shang to late Ming. Unabridged republication. 161 black-and-white draw-ings, photos. Total of 224pp. 8⅜ × 11¼. (Available in U.S. only) 25171-3 Pa. $14.95

VINCENT VAN GOGH: A Biography, Julius Meier-Graefe. Dynamic, penetrat-ing study of artist's life, relationship with brother, Theo, painting techniques, travels, more. Readable, engrossing. 160pp. 5⅜ × 8½. (Available in U.S. only) 25253-1 Pa. $4.95

HOW TO WRITE, Gertrude Stein. Gertrude Stein claimed anyone could understand her unconventional writing—here are clues to help. Fascinating improvisations, language experiments, explanations illuminate Stein's craft and the art of writing. Total of 414pp. 4⅝ × 6⅜. 23144-5 Pa. $6.95

ADVENTURES AT SEA IN THE GREAT AGE OF SAIL: Five Firsthand Narratives, edited by Elliot Snow. Rare true accounts of exploration, whaling, shipwreck, fierce natives, trade, shipboard life, more. 33 illustrations. Introduction. 353pp. 5⅜ × 8½. 25177-2 Pa. $9.95

THE HERBAL OR GENERAL HISTORY OF PLANTS, John Gerard. Classic descriptions of about 2,850 plants—with over 2,700 illustrations—includes Latin and English names, physical descriptions, varieties, time and place of growth, more. 2,706 illustrations. xlv + 1,678pp. 8½ × 12¼. 23147-X Cloth. $75.00

DOROTHY AND THE WIZARD IN OZ, L. Frank Baum. Dorothy and the Wizard visit the center of the Earth, where people are vegetables, glass houses grow and Oz characters reappear. Classic sequel to *Wizard of Oz.* 256pp. 5⅜ × 8. 24714-7 Pa. $5.95

SONGS OF EXPERIENCE: Facsimile Reproduction with 26 Plates in Full Color, William Blake. This facsimile of Blake's original "Illuminated Book" reproduces 26 full-color plates from a rare 1826 edition. Includes "The Tyger," "London," "Holy Thursday," and other immortal poems. 26 color plates. Printed text of poems. 48pp. 5¼ × 7. 24636-1 Pa. $3.95

SONGS OF INNOCENCE, William Blake. The first and most popular of Blake's famous "Illuminated Books," in a facsimile edition reproducing all 31 brightly colored plates. Additional printed text of each poem. 64pp. 5¼ × 7. 22764-2 Pa. $3.95

PRECIOUS STONES, Max Bauer. Classic, thorough study of diamonds, rubies, emeralds, garnets, etc.: physical character, occurrence, properties, use, similar topics. 20 plates, 8 in color. 94 figures. 659pp. 6⅛ × 9¼. 21910-0, 21911-9 Pa., Two-vol. set $15.90

ENCYCLOPEDIA OF VICTORIAN NEEDLEWORK, S. F. A. Caulfeild and Blanche Saward. Full, precise descriptions of stitches, techniques for dozens of needlecrafts—most exhaustive reference of its kind. Over 800 figures. Total of 679pp. 8⅛ × 11. 22800-2, 22801-0 Pa., Two-vol. set $23.90

THE MARVELOUS LAND OF OZ, L. Frank Baum. Second Oz book, the Scarecrow and Tin Woodman are back with hero named Tip, Oz magic. 136 illustrations. 287pp. 5⅜ × 8½. 20692-0 Pa. $5.95

WILD FOWL DECOYS, Joel Barber. Basic book on the subject, by foremost authority and collector. Reveals history of decoy making and rigging, place in American culture, different kinds of decoys, how to make them, and how to use them. 140 plates. 156pp. 7⅞ × 10¾. 20011-6 Pa. $8.95

HISTORY OF LACE, Mrs. Bury Palliser. Definitive, profusely illustrated chronicle of lace from earliest times to late 19th century. Laces of Italy, Greece, England, France, Belgium, etc. Landmark of needlework scholarship. 266 illustrations. 672pp. 6⅛ × 9¼. 24742-2 Pa. $16.95

SUNDIALS, Albert Waugh. Far and away the best, most thorough coverage of ideas, mathematics concerned, types, construction, adjusting anywhere. Over 100 illustrations. 230pp. 5⅜ × 8½. 22947-5 Pa. $5.95

PICTURE HISTORY OF THE NORMANDIE: With 190 Illustrations, Frank O. Braynard. Full story of legendary French ocean liner: Art Deco interiors, design innovations, furnishings, celebrities, maiden voyage, tragic fire, much more. Extensive text. 144pp. 8⅜ × 11¾. 25257-4 Pa. $10.95

THE FIRST AMERICAN COOKBOOK: A Facsimile of "American Cookery," 1796, Amelia Simmons. Facsimile of the first American-written cookbook published in the United States contains authentic recipes for colonial favorites—pumpkin pudding, winter squash pudding, spruce beer, Indian slapjacks, and more. Introductory Essay and Glossary of colonial cooking terms. 80pp. 5⅜ × 8½. 24710-4 Pa. $3.50

101 PUZZLES IN THOUGHT AND LOGIC, C. R. Wylie, Jr. Solve murders and robberies, find out which fishermen are liars, how a blind man could possibly identify a color—purely by your own reasoning! 107pp. 5⅜ × 8½. 20367-0 Pa. $2.95

ANCIENT EGYPTIAN MYTHS AND LEGENDS, Lewis Spence. Examines animism, totemism, fetishism, creation myths, deities, alchemy, art and magic, other topics. Over 50 illustrations. 432pp. 5⅜ × 8½. 26525-0 Pa. $8.95

ANTHROPOLOGY AND MODERN LIFE, Franz Boas. Great anthropologist's classic treatise on race and culture. Introduction by Ruth Bunzel. Only inexpensive paperback edition. 255pp. 5⅜ × 8½. 25245-0 Pa. $6.95

THE TALE OF PETER RABBIT, Beatrix Potter. The inimitable Peter's terrifying adventure in Mr. McGregor's garden, with all 27 wonderful, full-color Potter illustrations. 55pp. 4¼ × 5½. (Available in U.S. only) 22827-4 Pa. $1.75

THREE PROPHETIC SCIENCE FICTION NOVELS, H. G. Wells. *When the Sleeper Wakes, A Story of the Days to Come* and *The Time Machine* (full version). 335pp. 5⅜ × 8½. (Available in U.S. only) 20605-X Pa. $8.95

APICIUS COOKERY AND DINING IN IMPERIAL ROME, edited and translated by Joseph Dommers Vehling. Oldest known cookbook in existence offers readers a clear picture of what foods Romans ate, how they prepared them, etc. 49 illustrations. 301pp. 6⅛ × 9¼. 23563-7 Pa. $7.95

SHAKESPEARE LEXICON AND QUOTATION DICTIONARY, Alexander Schmidt. Full definitions, locations, shades of meaning of every word in plays and poems. More than 50,000 exact quotations. 1,485pp. 6½ × 9¼. 22726-X, 22727-8 Pa., Two-vol. set $31.90

THE WORLD'S GREAT SPEECHES, edited by Lewis Copeland and Lawrence W. Lamm. Vast collection of 278 speeches from Greeks to 1970. Powerful and effective models; unique look at history. 842pp. 5⅜ × 8½. 20468-5 Pa. $12.95

CATALOG OF DOVER BOOKS

SIR HARRY HOTSPUR OF HUMBLETHWAITE, Anthony Trollope. Incisive, unconventional psychological study of a conflict between a wealthy baronet, his idealistic daughter, and their scapegrace cousin. The 1870 novel in its first inexpensive edition in years. 250pp. 5⅜ × 8½. 24953-0 Pa. $6.95

LASERS AND HOLOGRAPHY, Winston E. Kock. Sound introduction to burgeoning field, expanded (1981) for second edition. Wave patterns, coherence, lasers, diffraction, zone plates, properties of holograms, recent advances. 84 illustrations. 160pp. 5⅜ × 8¼. (Except in United Kingdom) 24041-X Pa. $3.95

INTRODUCTION TO ARTIFICIAL INTELLIGENCE: Second, Enlarged Edition, Philip C. Jackson, Jr. Comprehensive survey of artificial intelligence—the study of how machines (computers) can be made to act intelligently. Includes introductory and advanced material. Extensive notes updating the main text. 132 black-and-white illustrations. 512pp. 5⅜ × 8½. 24864-X Pa. $10.95

HISTORY OF INDIAN AND INDONESIAN ART, Ananda K. Coomaraswamy. Over 400 illustrations illuminate classic study of Indian art from earliest Harappa finds to early 20th century. Provides philosophical, religious and social insights. 304pp. 6⅜ × 9⅜. 25005-9 Pa. $11.95

THE GOLEM, Gustav Meyrink. Most famous supernatural novel in modern European literature, set in Ghetto of Old Prague around 1890. Compelling story of mystical experiences, strange transformations, profound terror. 13 black-and-white illustrations. 224pp. 5⅜ × 8½. (Available in U.S. only) 25025-3 Pa. $6.95

PICTORIAL ENCYCLOPEDIA OF HISTORIC ARCHITECTURAL PLANS, DETAILS AND ELEMENTS: With 1,880 Line Drawings of Arches, Domes, Doorways, Facades, Gables, Windows, etc., John Theodore Haneman. Sourcebook of inspiration for architects, designers, others. Bibliography. Captions. 141pp. 9 × 12. 24605-1 Pa. $7.95

BENCHLEY LOST AND FOUND, Robert Benchley. Finest humor from early 30s, about pet peeves, child psychologists, post office and others. Mostly unavailable elsewhere. 73 illustrations by Peter Arno and others. 183pp. 5⅜ × 8½. 22410-4 Pa. $4.95

ERTÉ GRAPHICS, Erté. Collection of striking color graphics: *Seasons, Alphabet, Numerals, Aces* and *Precious Stones*. 50 plates, including 4 on covers. 48pp. 9⅜ × 12¼. 23580-7 Pa. $7.95

THE JOURNAL OF HENRY D. THOREAU, edited by Bradford Torrey, F. H. Allen. Complete reprinting of 14 volumes, 1837–61, over two million words; the sourcebooks for *Walden*, etc. Definitive. All original sketches, plus 75 photographs. 1,804pp. 8½ × 12¼. 20312-3, 20313-1 Cloth., Two-vol. set $130.00

CASTLES: Their Construction and History, Sidney Toy. Traces castle development from ancient roots. Nearly 200 photographs and drawings illustrate moats, keeps, baileys, many other features. Caernarvon, Dover Castles, Hadrian's Wall, Tower of London, dozens more. 256pp. 5⅜ × 8¼. 24898-4 Pa. $6.95

CATALOG OF DOVER BOOKS

AMERICAN CLIPPER SHIPS: 1833–1858, Octavius T. Howe & Frederick C. Matthews. Fully-illustrated, encyclopedic review of 352 clipper ships from the period of America's greatest maritime supremacy. Introduction. 109 halftones. 5 black-and-white line illustrations. Index. Total of 928pp. 5⅜ × 8½.
25115-2, 25116-0 Pa., Two-vol. set $17.90

TOWARDS A NEW ARCHITECTURE, Le Corbusier. Pioneering manifesto by great architect, near legendary founder of "International School." Technical and aesthetic theories, views on industry, economics, relation of form to function, "mass-production spirit," much more. Profusely illustrated. Unabridged translation of 13th French edition. Introduction by Frederick Etchells. 320pp. 6⅛ × 9¼. (Available in U.S. only)
25023-7 Pa. $8.95

THE BOOK OF KELLS, edited by Blanche Cirker. Inexpensive collection of 32 full-color, full-page plates from the greatest illuminated manuscript of the Middle Ages, painstakingly reproduced from rare facsimile edition. Publisher's Note. Captions. 32pp. 9⅜ × 12¼.
24345-1 Pa. $5.95

BEST SCIENCE FICTION STORIES OF H. G. WELLS, H. G. Wells. Full novel *The Invisible Man*, plus 17 short stories: "The Crystal Egg," "Aepyornis Island," "The Strange Orchid," etc. 303pp. 5⅜ × 8½. (Available in U.S. only)
21531-8 Pa. $6.95

AMERICAN SAILING SHIPS: Their Plans and History, Charles G. Davis. Photos, construction details of schooners, frigates, clippers, other sailcraft of 18th to early 20th centuries—plus entertaining discourse on design, rigging, nautical lore, much more. 137 black-and-white illustrations. 240pp. 6⅛ × 9¼.
24658-2 Pa. $6.95

ENTERTAINING MATHEMATICAL PUZZLES, Martin Gardner. Selection of author's favorite conundrums involving arithmetic, money, speed, etc., with lively commentary. Complete solutions. 112pp. 5⅜ × 8½.
25211-6 Pa. $3.50

THE WILL TO BELIEVE, HUMAN IMMORTALITY, William James. Two books bound together. Effect of irrational on logical, and arguments for human immortality. 402pp. 5⅜ × 8½.
20291-7 Pa. $8.95

THE HAUNTED MONASTERY and THE CHINESE MAZE MURDERS, Robert Van Gulik. 2 full novels by Van Gulik continue adventures of Judge Dee and his companions. An evil Taoist monastery, seemingly supernatural events; overgrown topiary maze that hides strange crimes. Set in 7th-century China. 27 illustrations. 328pp. 5⅜ × 8½.
23502-5 Pa. $6.95

CELEBRATED CASES OF JUDGE DEE (DEE GOONG AN), translated by Robert Van Gulik. Authentic 18th-century Chinese detective novel; Dee and associates solve three interlocked cases. Led to Van Gulik's own stories with same characters. Extensive introduction. 9 illustrations. 237pp. 5⅜ × 8½.
23337-5 Pa. $5.95

Prices subject to change without notice.

Available at your book dealer or write for free catalog to Dept. GI, Dover Publications, Inc., 31 East 2nd St., Mineola, N.Y. 11501. Dover publishes more than 175 books each year on science, elementary and advanced mathematics, biology, music, art, literary history, social sciences and other areas.